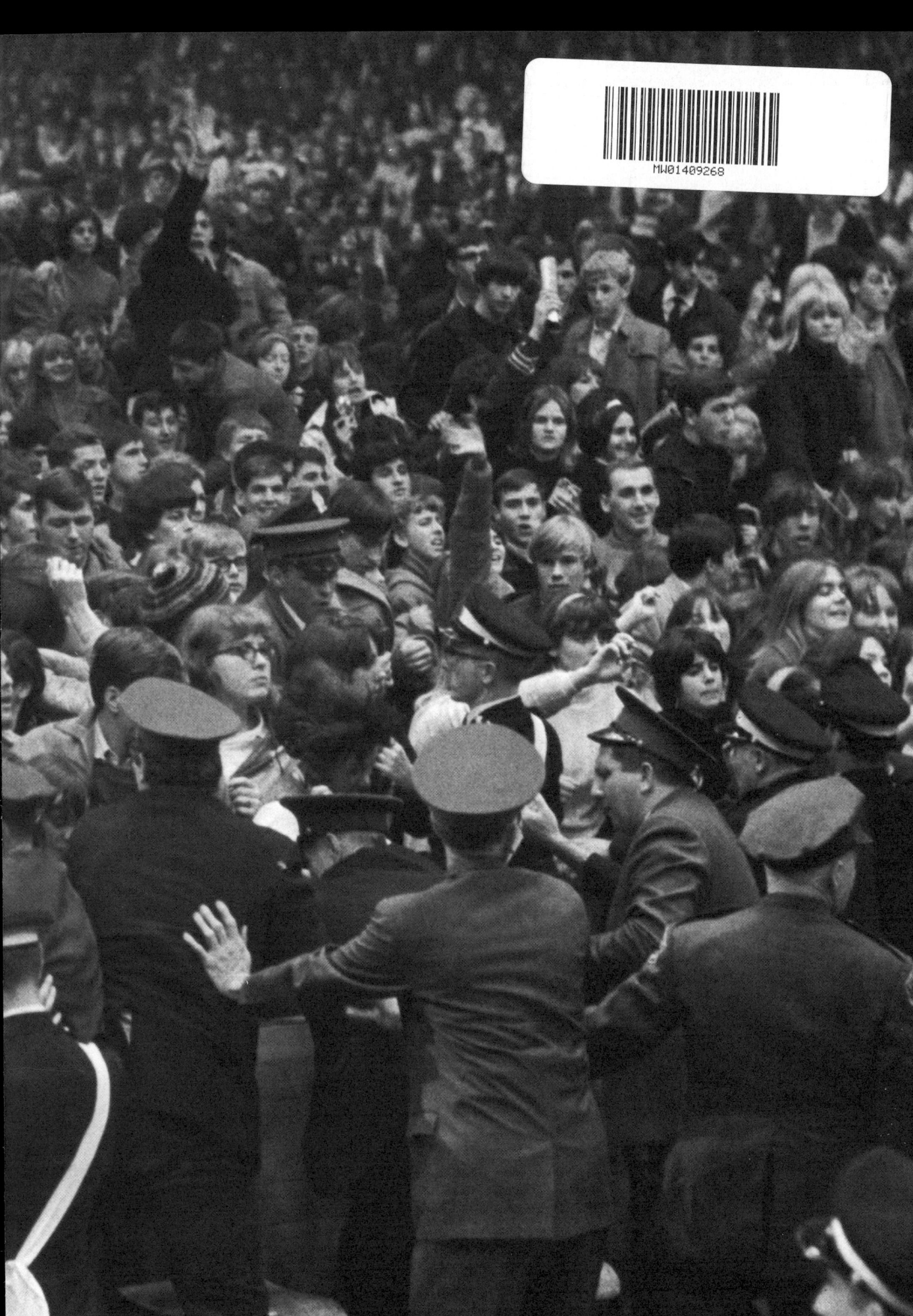

THE ROLLING STONES
RARE AND UNSEEN

Published in 2024 by Welbeck

An imprint of Welbeck Non-Fiction Limited, part of Welbeck Publishing Group.

Offices in: London - 20 Mortimer Street, London W1T 3JW & Sydney
- Level 17, 207 Kent St, Sydney NSW 2000 Australia

www.welbeckpublishing.com

Photography © Gered Mankowitz and ABG Images (UK) Ltd 2024
Text © Gered Mankowitz, Keith Richards, Will Hodgkinson, Ben Sisario, Leah Kardos, Terry Newman, Peter York, Andrew Loog Oldham 2024
Design © Welbeck Non-Fiction Limited, part of Welbeck Publishing Group 2024

All rights reserved. No part of this publication may be reproduced, stored in a retrieval system, or transmitted in any form or by any means, electronically, mechanical, photocopying, recording or otherwise, without the prior permission of the copyright owners and the publishers.

A CIP catalogue record for this book is available from the British Library

ISBN: 978-1-80279-733-6

Publisher: Joe Cottington
Design: James Empringham
Production: Rachel Burgess

Printed in China

10 9 8 7 6 5 4 3 2 1

THE ROLLING STONES
RARE AND UNSEEN

**PHOTOGRAPHS BY
GERED MANKOWITZ**

WELBECK

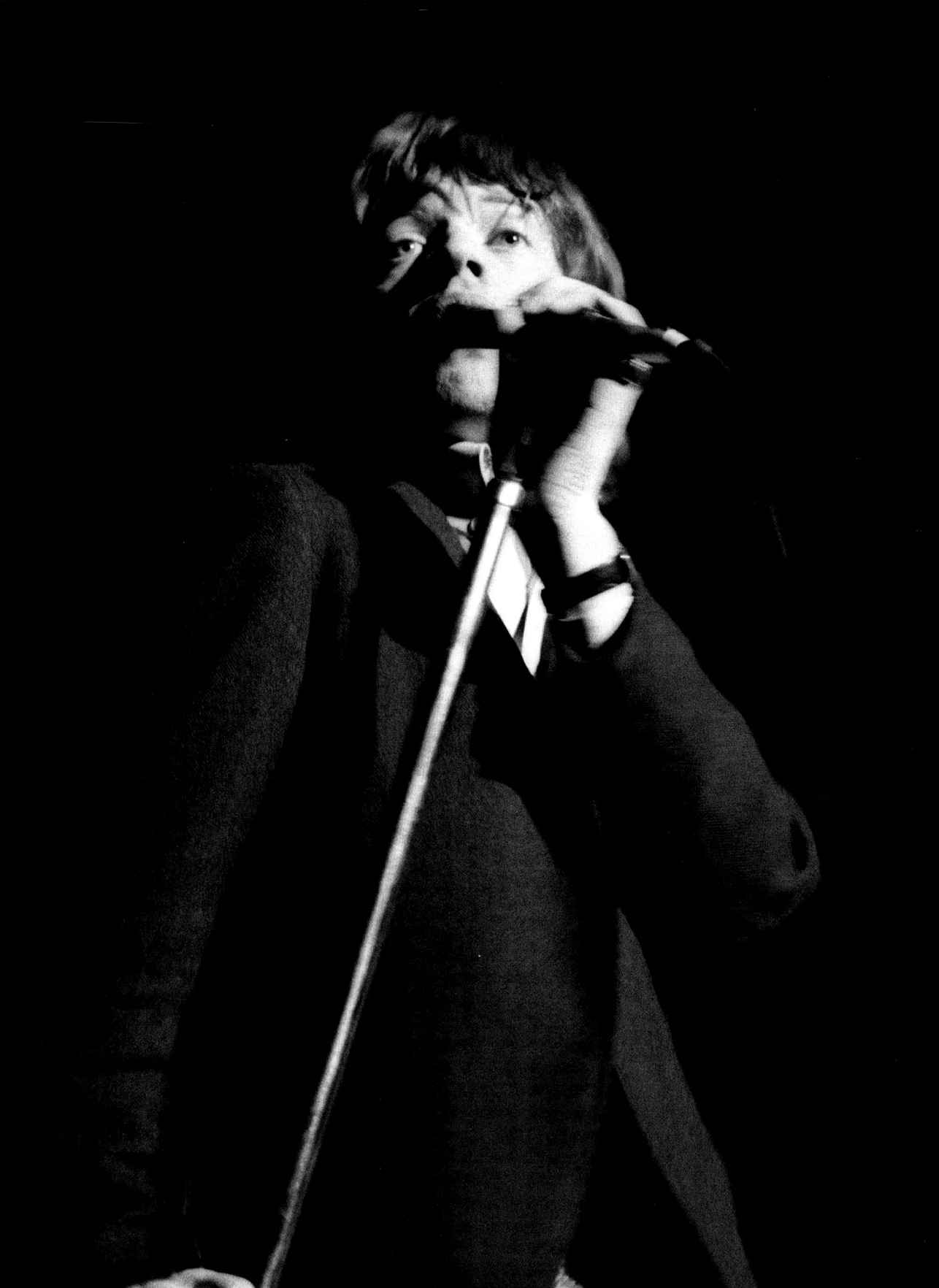

Contents

Foreword, Keith Richards		6
Introduction		8
Mason's Yard	**1965**	16
The Sound of the Stones, Will Hodgkinson		52
Taking the States	**1965**	58
On Stage	**1965**	94
The British Invasion, Ben Sisario		122
Recording, Hollywood	**1965**	128
Laying the Blueprint, Dr Leah Kardos		142
Stones at Home	**1966**	148
The Stones and Style, Terry Newman		196
Primrose Hill	**1966**	202
The London Palladium	**1967**	220
Olympic Studios	**1967**	238
A Different Class, Peter York		246
Afterword, Andrew Loog Oldham		252
Acknowledgements		254

Foreword
Keith Richards

In front of me I have a black and white photo of myself kitted out in true Western garb down to a Colt 45 revolver and a Winchester repeating rifle. (When you're deep in the back country of Arizona you are dead without one.) I'm standing in front of a beautiful chestnut quarter horse, who became my friend and my tutor for about a week. I look ludicrously young but very much at home. The other person there (not shown in the shot) was Gered, and we were surely two of the most unlikely people to meet in the Arizona desert. He's not visible because Gered took the photo. I should have taken one of him because he looked the perfect greenhorn: cherubic, bespectacled, always with a camera ready for the fast draw. Those nights beside the fire sleeping on our saddles and trying to keep the beans pacified has been indelibly stamped in my mind. (Also the look on Gered's face as our old Indian guide blasted away at a mountain lion that got too close for comfort.) He once took me to meet his father on a drive in the English countryside. Wolf must have wondered what his son had dragged in, although it was a very pleasant afternoon. We've met briefly over the last (mere) 50 years, yet I always feel a warm glow when I think of the photographer on the range and I wonder, does he still carry a camera wherever he goes…

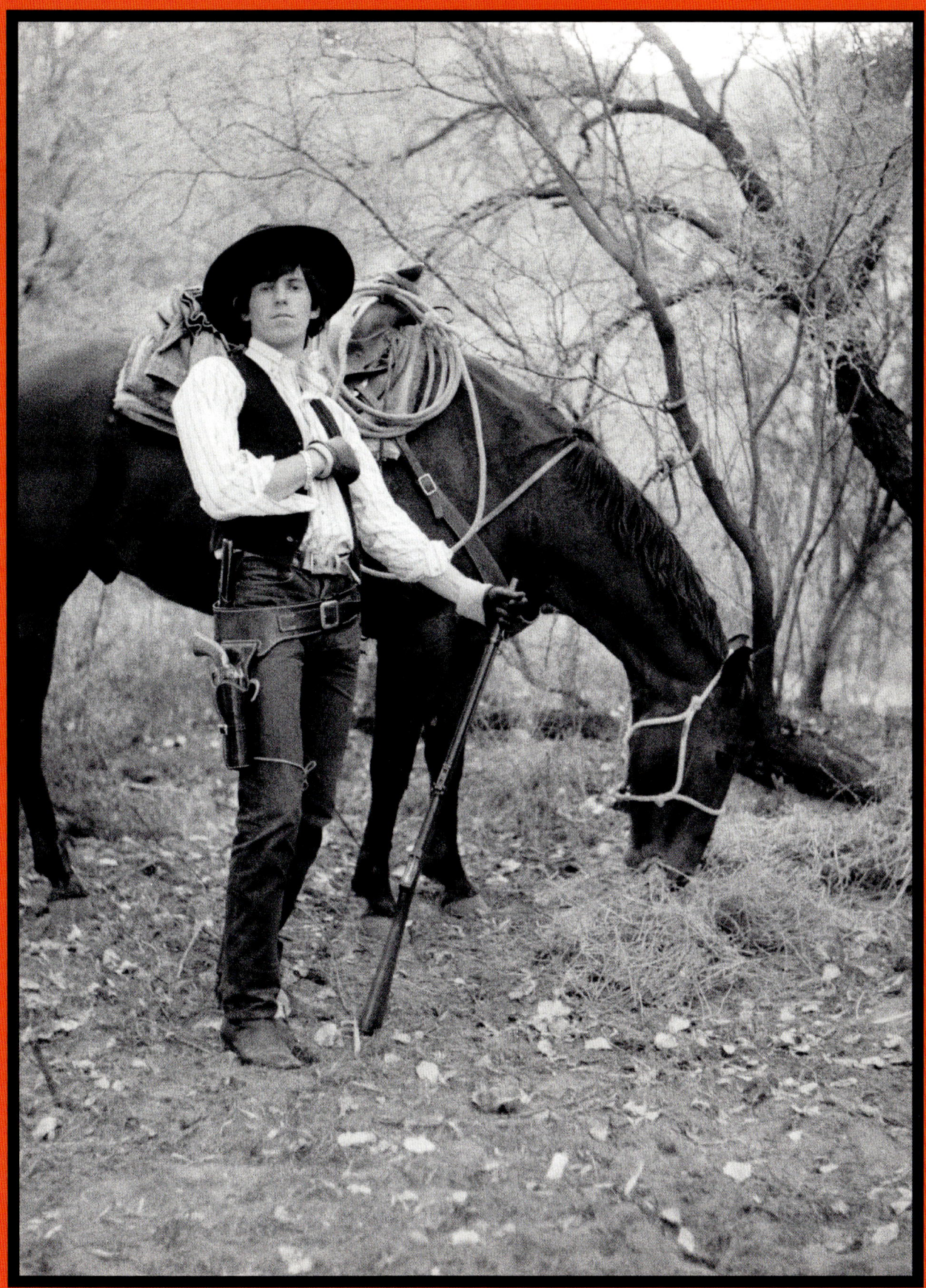

KEITH RICHARDS

Introduction

I moved into my first studio at 9 Mason's Yard, just behind Piccadilly in Central London, over 60 years ago, when I was still just 16 years old.

It was through my friendship and work with Marianne Faithfull, who was managed by Andrew Loog Oldham, that I came to work with the Rolling Stones. Andrew also managed and produced the Stones and had been impressed with one session in particular which I had shot with Marianne, so he asked me to come and work with him and his other band.

When I first met Mick, Brian, Keith, Charlie and Bill at Andrew's office late in 1964, they were friendly and easy to get along with, and they appeared enthusiastic about shooting with me. But the first session with them at Mason's Yard didn't actually happen until the first half of 1965. That first session went very well, and I found myself working with the band again and again in the years that followed, making some very good friends in the process.

I remember one particular trip with Keith, which was very special and lives long in the memory. It was during the band's second 1965 tour of the US, on which I accompanied them throughout. We had a few days off and most of the band, together with Andrew, decided to go to Las Vegas. Keith said to me that he really didn't like Las Vegas and thought he might go riding in Arizona for a couple of days. He asked whether I wanted to join him, together with Ronnie Schneider, who was Allen Klein's nephew and the money man on the tour, as well as being a great character. Of course, the answer was a resounding "Yes, please!". Keith had arranged everything, a two-day trip on horseback with a guide, sleeping under the stars, herding cattle, the full works. En route to the ranch we even stopped off to load up with Stetsons, chaps and a few weapons. Keith paid for it all and brought me a very tall Stetson, as well as a full Billy the Kid outfit for himself. Keith looked perfect, of course, though Ronnie and I looked like classic greenhorns. But, wow, did we have a great time. It was a marvellous adventure, joyfully remembered by all of us.

During my time working with the band, I worked on a range of sessions and produced images for several album covers, including *Out of Our Heads* (or *December's Children...*, as it was known

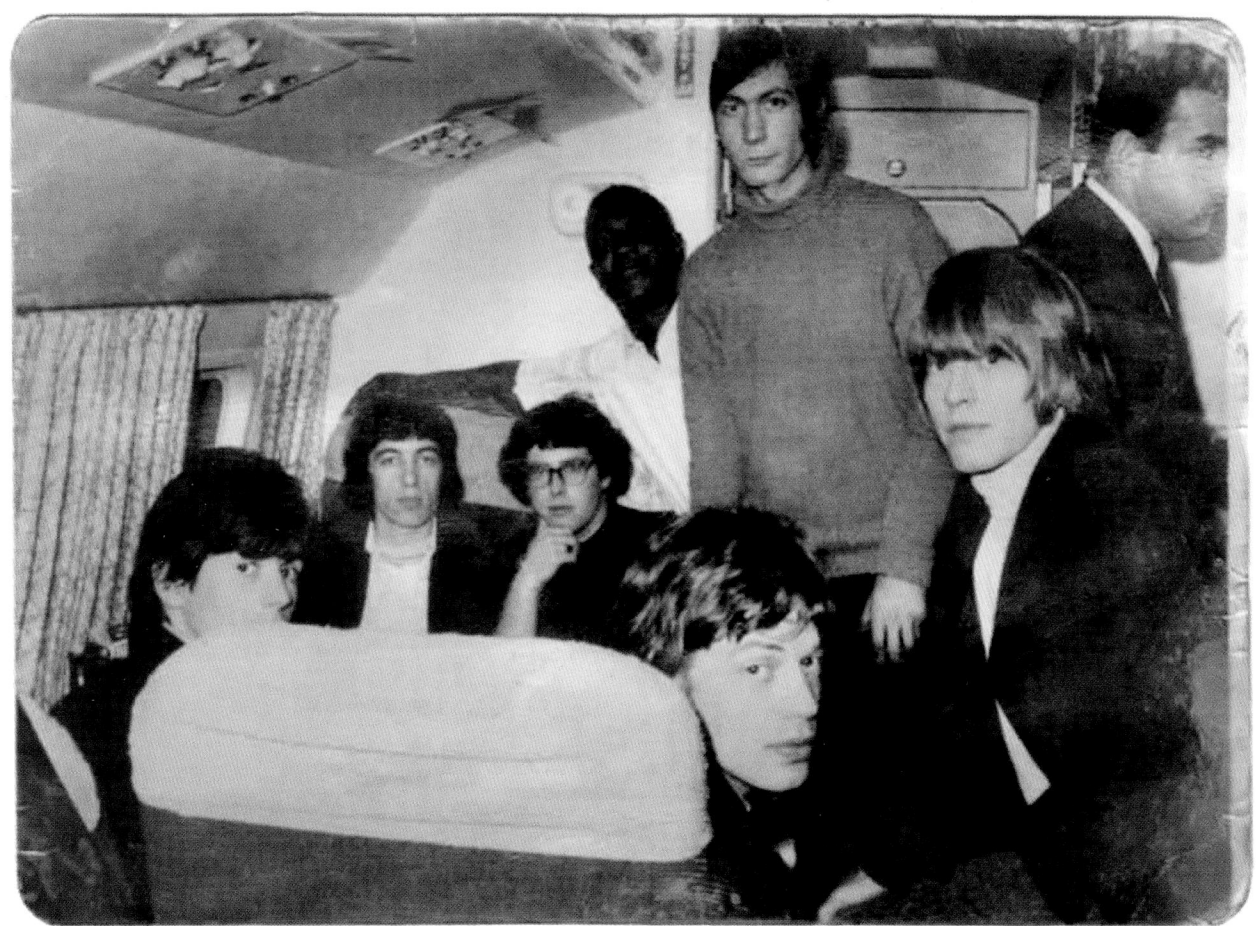

A recently discovered photograph of me (centre) with the band, possibly taken by one of Patti LaBelle and the Bluebelles – the man standing behind me is Bernard Montague, manager of the Bluebelles, the support act on that 1965 US tour. Exiting the frame to the right is Ronnie Schneider, a dear friend of mine on tour.

in the US) and *Between the Buttons*. Though I stopped working with the band at that point, I continued to work with Andrew at his independent record company Immediate Records – and with many other artists, managers and labels in the years to come.

In the years immediately after my split with the band, interest in the photographs I had taken with them was sporadic, and I kept the negatives and a few transparencies somewhat haphazardly, stashed in shopping bags and stored under my desks in the several studios where I was based. This was until the early 1980s, when I was fortunate enough to have my first exhibition at the only photographic gallery in London back in those days, the Photographers Gallery in Covent Garden.

This show, called Pop People, was the first exhibition of music images ever shown in the UK – a turning point in how that body of work was viewed. It was a huge success and went on to tour the UK, with Arts Council support, for the next two years. As a result, I was asked to produce my first book on the Rolling Stones which was published in 1984, both in the UK and the US. With a steady and increasing interest in my archive, including the covers for various international rereleases of Rolling Stones recordings from the '60s, I began to review my

INTRODUCTION

archive in more depth and to improve its organization, leading up to a major London exhibition in Soho in 1992. This included many images of the Rolling Stones but also many other artists I had photographed over the years, including Jimi Hendrix, Kate Bush and Eurythmics.

As the 1990s progressed and more books and exhibitions followed, my work with the Stones became increasingly sought after. With the advent of digital post-production, I was able to revisit my original negatives and restore them back to their original condition, as well as to recover images that were previously unprintable by analogue means. Several other books and exhibitions followed. As a result, I felt that I knew the work inside out.

So, to be honest, the thought of going through hundreds of sheets of my Rolling Stones archive didn't excite me much when the idea for this project first came about. However, I couldn't pretend that I hadn't noticed on occasion the shot next to the famous one and wondered if it wasn't just as good – or even a little better. So, I began to go through the material, pulling out sheets of previously dismissed work that had been rejected – not, truth be told, after due consideration, but purely because we had previously selected an image from that roll, that venue, that moment. It was those initially chosen images that stuck and which were always shown.

The other consideration that brings a fresh light to this collection is the number of previously lost photographs I have been able to recover over the years. Crazy though it may seem now, at the time these images were shot, we didn't think that they had any value beyond the immediate moment. The record company was sent the original transparency for, say, an album cover – and that was it, I often never saw them again and we don't know whatever happened to them. Other times, film was simply lost over time, mislaid in an office move or some other mishap. Entire shoots have been lost. It seems wilfully neglectful now, but at the time we couldn't imagine that the photographs would have any life beyond their contemporary use. We certainly wouldn't have believed that the band would be around all this time later.

But over time I have been able to retrieve more and more images, sometimes through incredibly unlikely means. Often I'm helped by the fame that my Stones photographs have gained, which means they are now recognized. One time I was called by an employee of Decca Records, who found a whole tranche of my transparencies in a skip outside the office, presumably caught up in some office clear-out. He saw the photographs, understood their importance and had the decency to return them to me. Another image – the original negative for the *Out of Our Heads* cover itself – was lost for a long time, and only came back to me via a friend of mine, who chanced upon it, mislabelled and tucked away in an old file for an entirely different 1960s band, the Pretty Things.

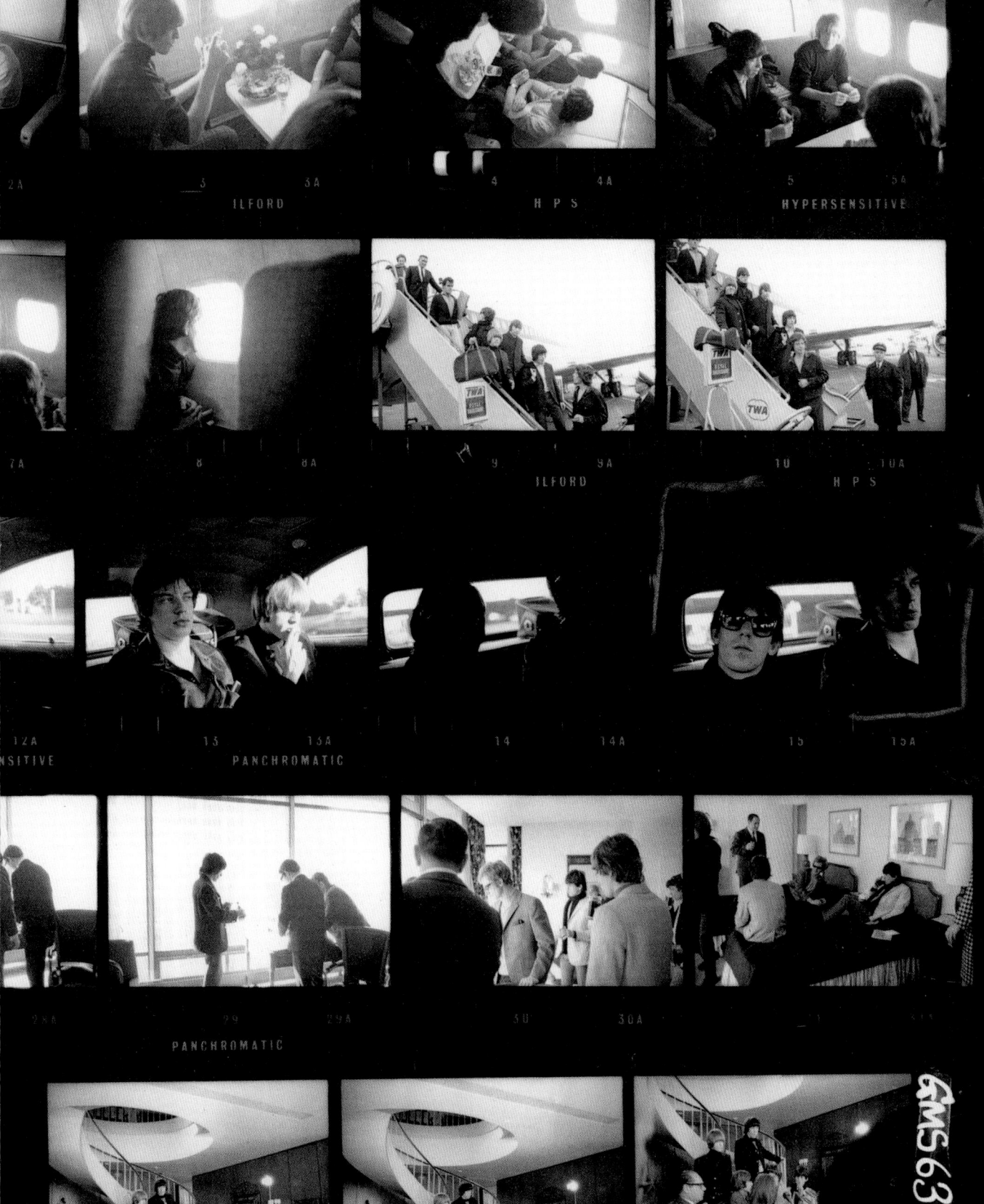

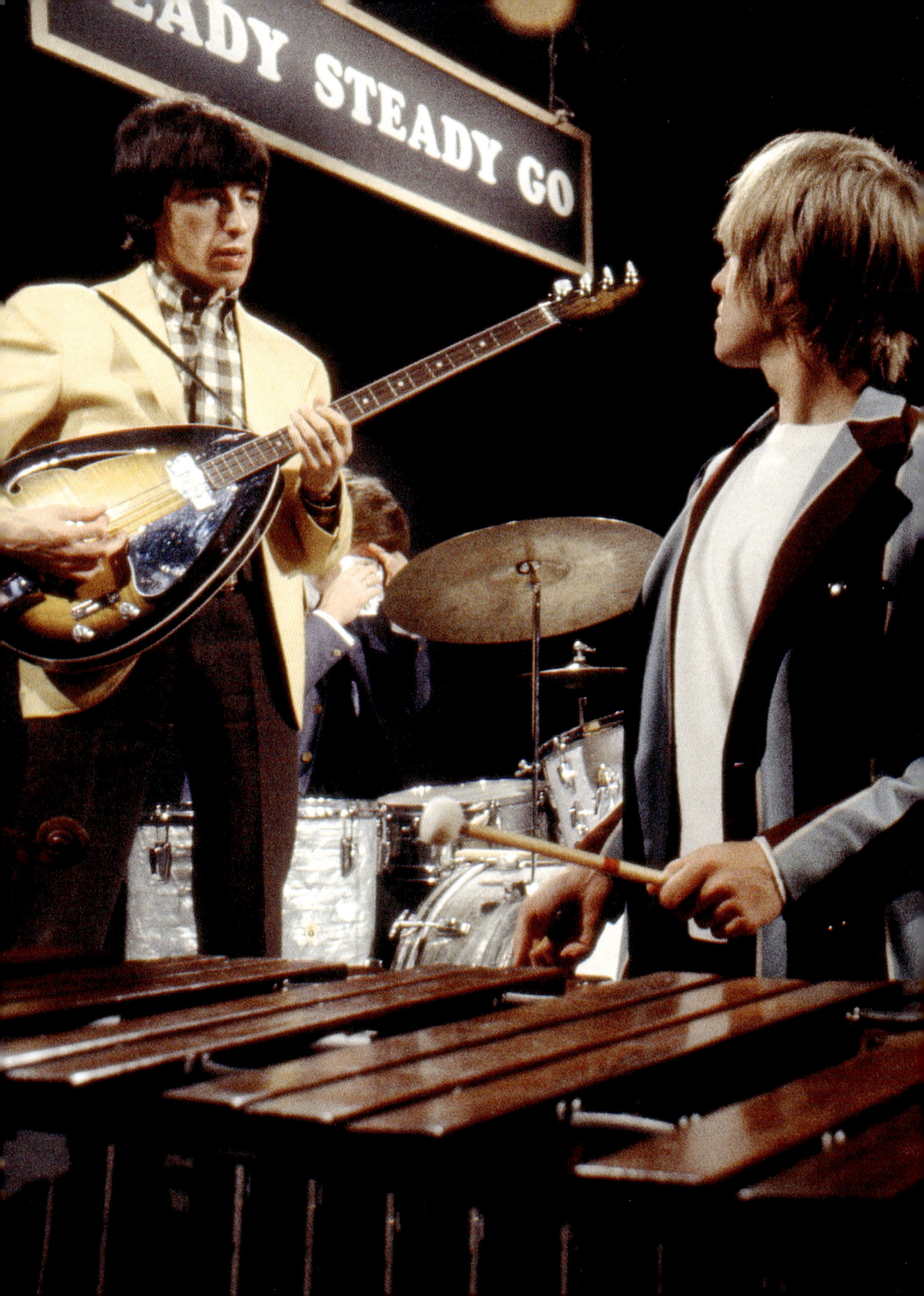

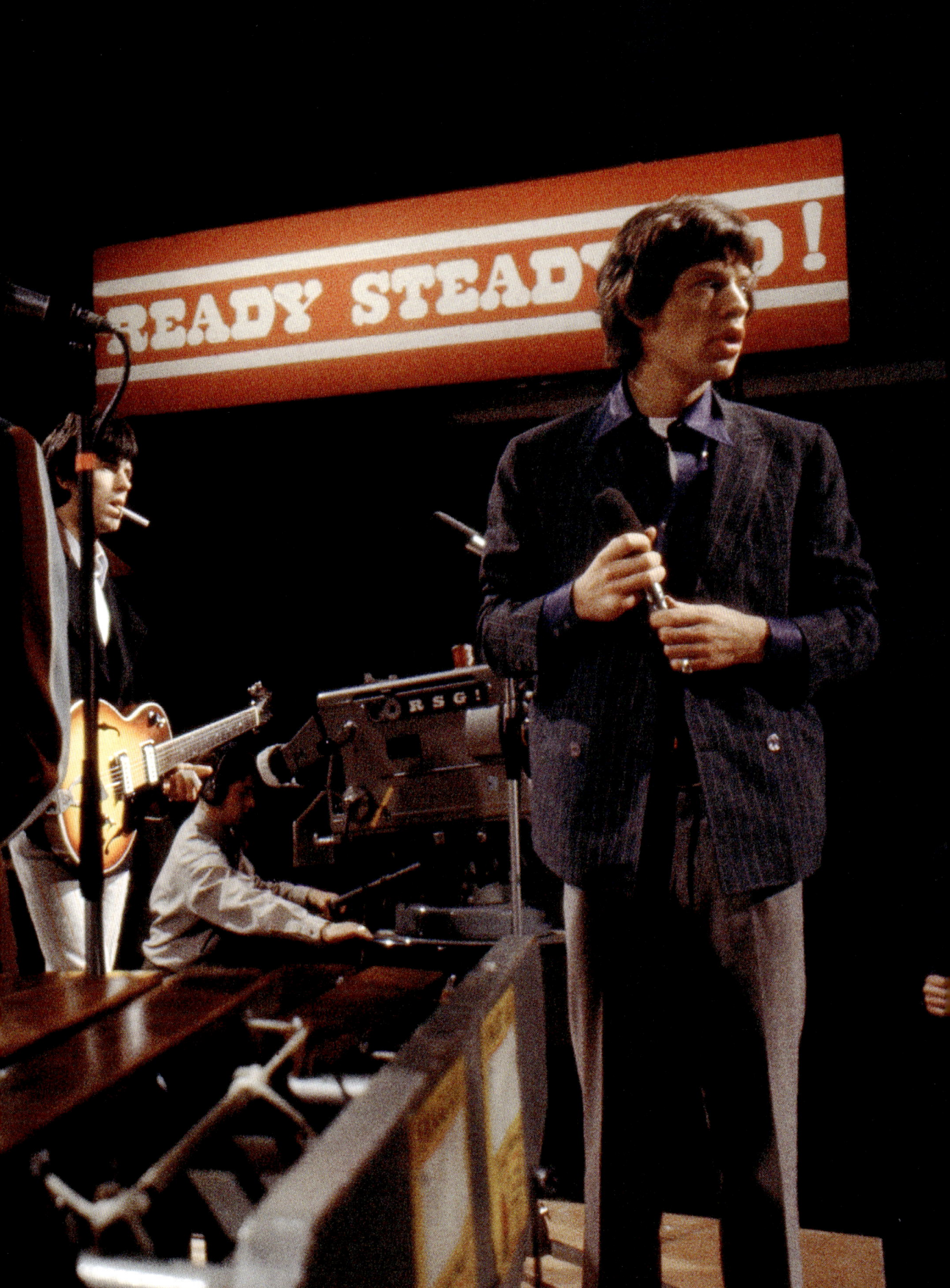

Slowly, it dawned on me that I actually had a hell of a lot of material here which had never been released, but which was really good and very interesting – even more so given the years that have now passed. These photographs were perhaps not quite as "on the button" as the original edit – they may have been looked over initially because, say, Keith was looking to one side, or Brian wasn't focused on my lens – but on review they have proven at least as fascinating as their better-known counterparts. In many instances, there were shots that had been completely missed and were even better than the original selection.

Part of the problem was that there was always an inclination to go for the famous shot in previous books and exhibitions, perhaps cropping it differently to change the dynamic. But suddenly, in looking back through the many, many contact sheets, sequences were revealed that are really good and which work in an entirely different way. Shots of the band performing, relaxing, recording in ways that had been missed before – and that might make sense now.

I also decided I wanted to include essays in the book, looking at the different aspects of the Stones' story in that unique period in the mid- to late 1960s, when the world was at their feet. So I have asked people from all walks of cultural life – music, fashion and more besides – to contribute pieces looking at the band and their work at that time from their own points of view. I think that, when combined with these new images, they paint a new and fascinating portrait of the Rolling Stones.

It was exciting and quite addictive, I have to say, rediscovering these moments in time, many I had completely forgotten about, which had lain unseen by anybody for the best part of *sixty bloody years*!

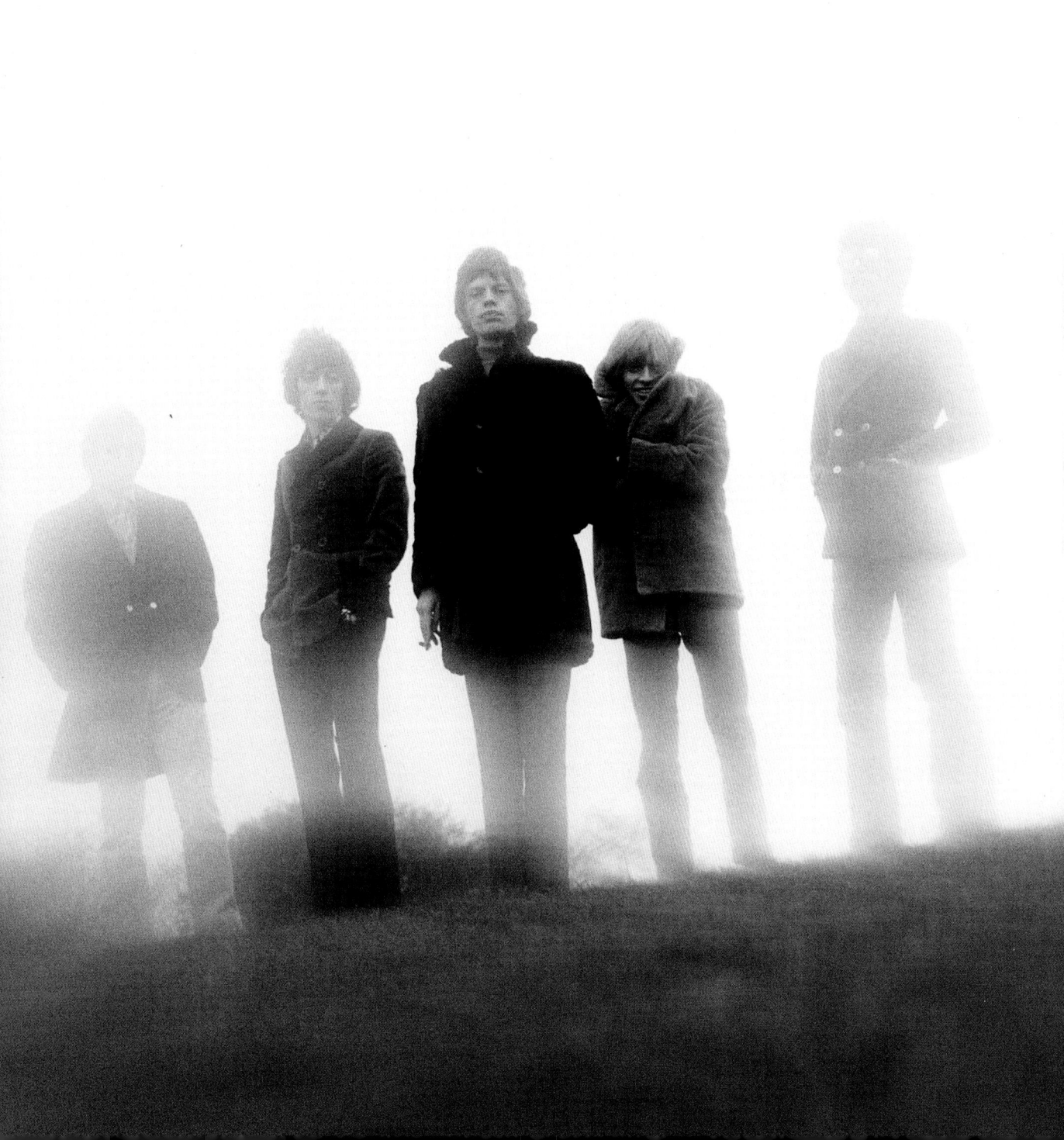

Mason's Yard

1965

There was no brief for this, my first session with the band, beyond the pressure of being told by Andrew that if I didn't do a good job, then he would have to take them back to David Bailey!

In those days I would always shoot a few rolls in the studio and several others outside in the area around Mason's Yard. It so happened that there was a large building site in Ormond Yard, which was on the other side of my studio, and I thought it might make a gritty and decidedly unglamorous background for the band. There were piles of bricks to climb on and various bits of equipment and general builder's paraphernalia lying around. By then I had already learned what to do if I wanted my photographs to stand a chance of being selected for an album cover or a poster: I needed to make sure that my composition allowed room for the album title and name of the band as well as the record company logo.

Throughout this session the band were wonderful and patient subjects, responding to my simple directions without questions and working to the camera with enthusiasm and generosity, while ignoring the endless banter from Andrew behind me. After a few hours, which included a boisterous game of football in the yard, it was done and dusted. The band left, and I went to the darkroom to process the film.

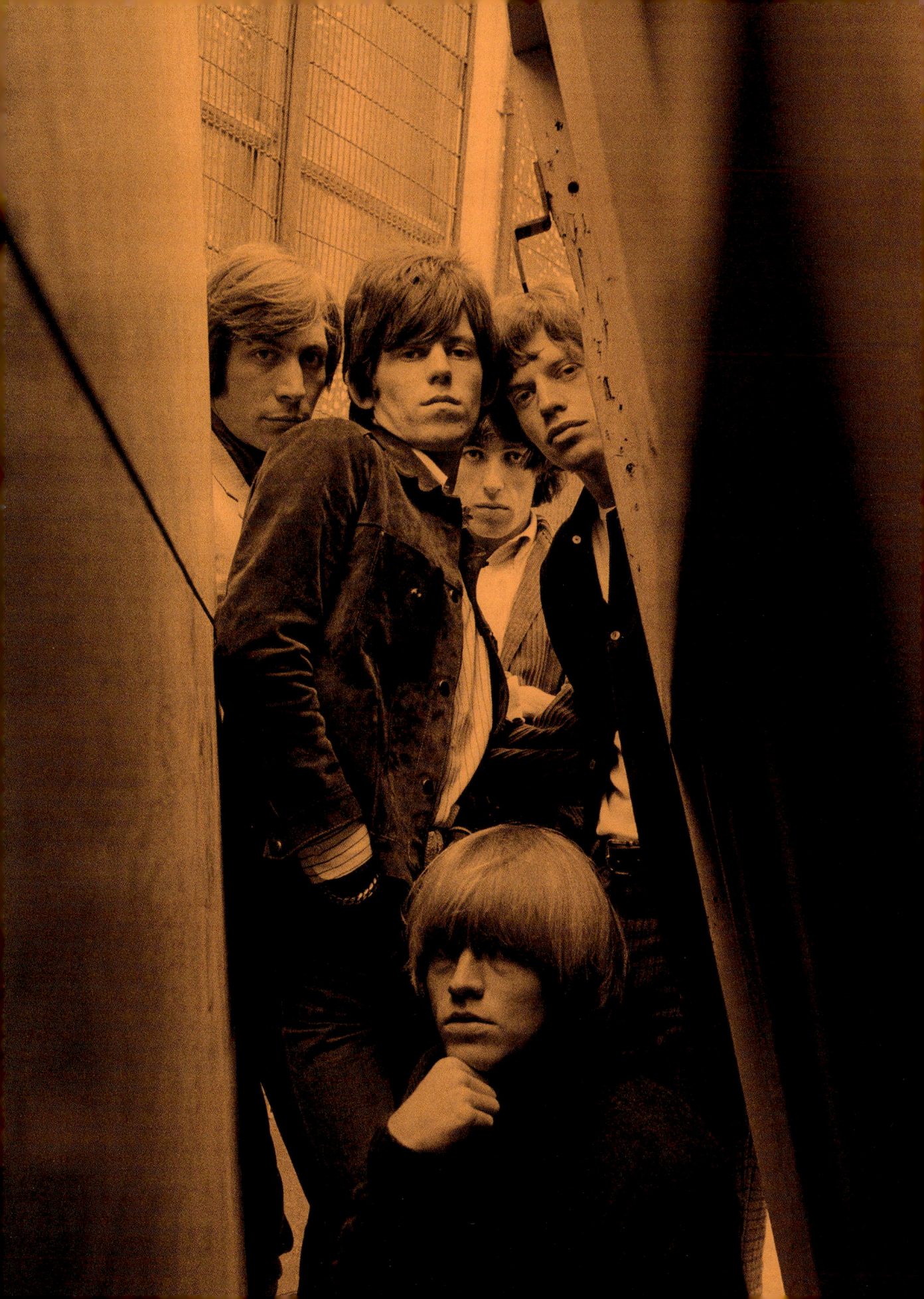

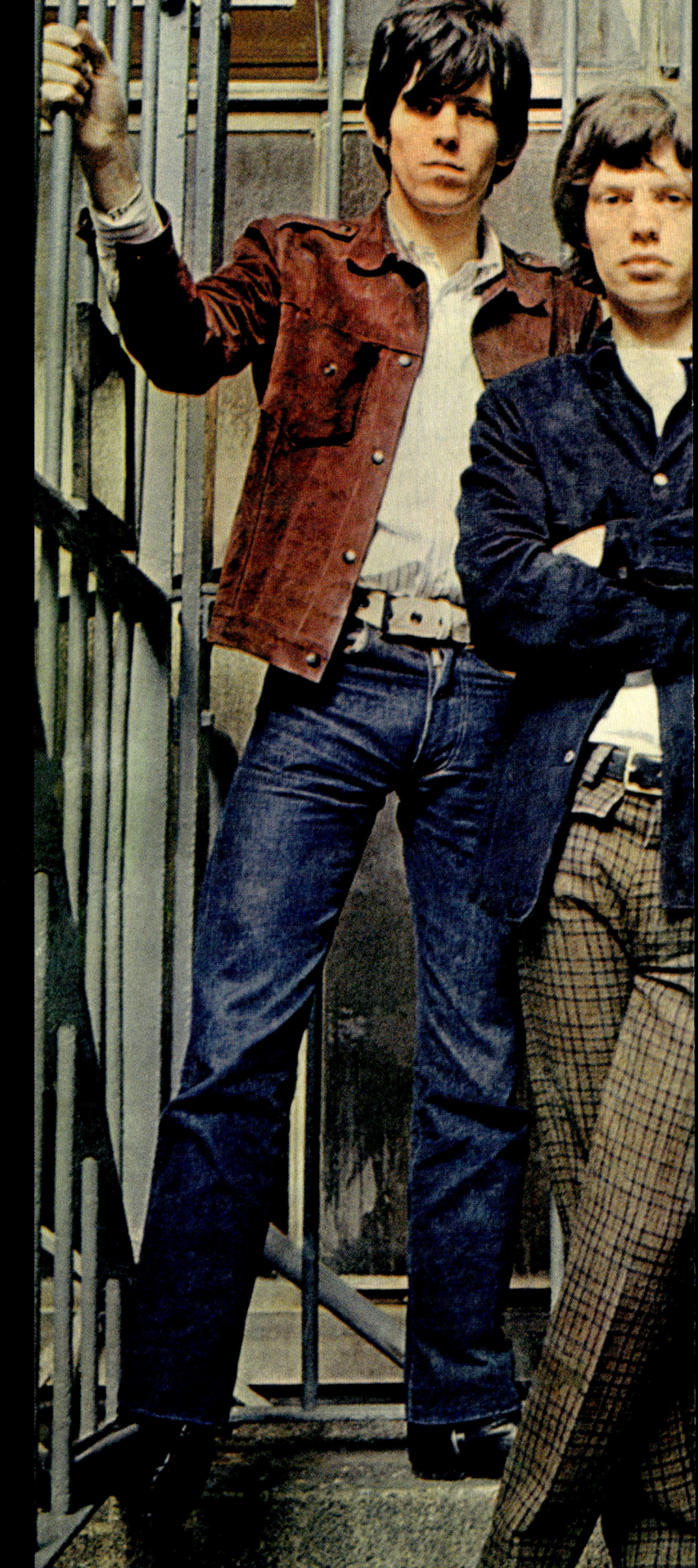

A long-lost photograph from that first Mason's Yard session, this is one of several colour images that disappeared shortly after being taken and has only very recently resurfaced. It was shot on the steps outside my studio, and used as the cover of the 1965 US tour programme.

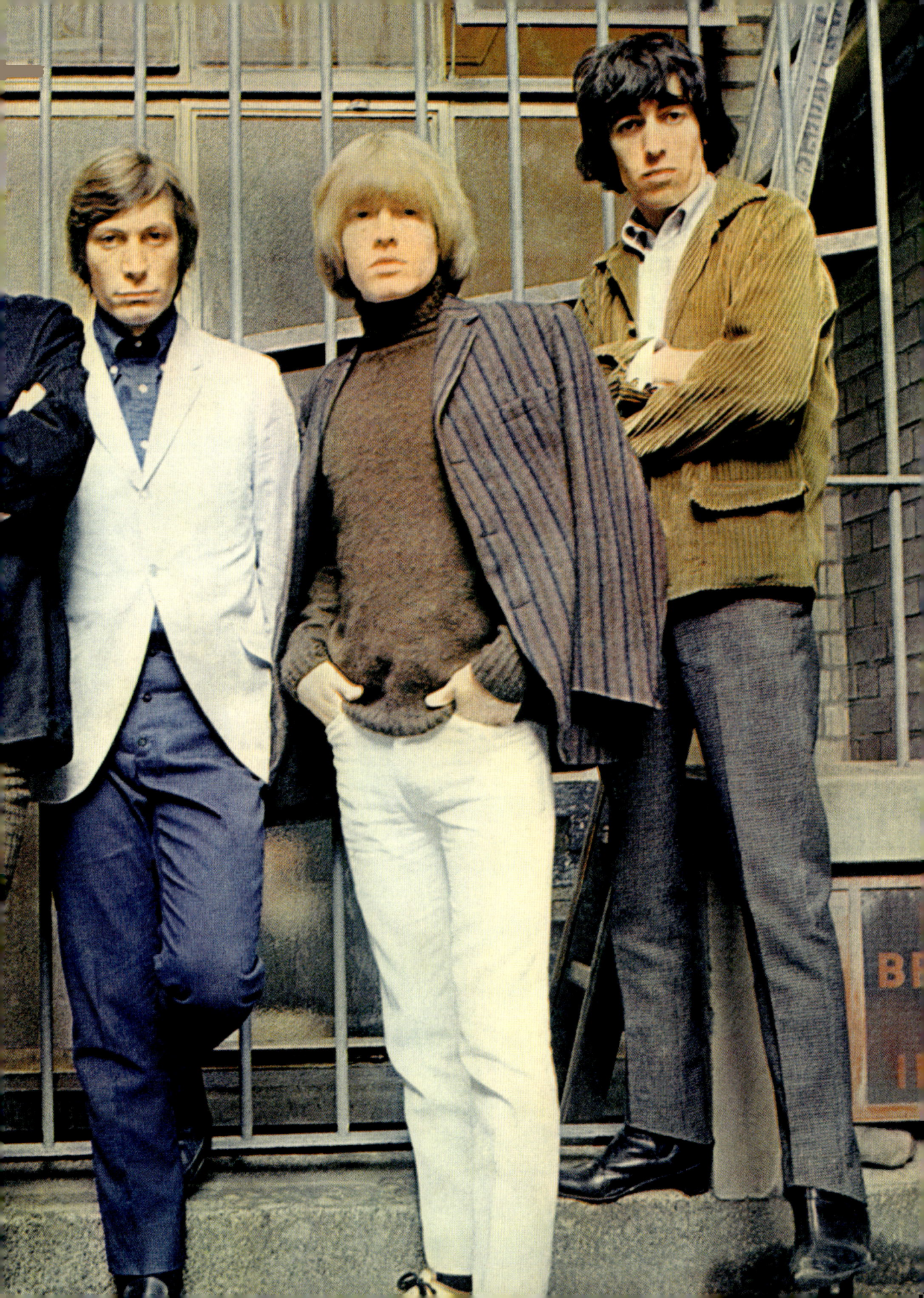

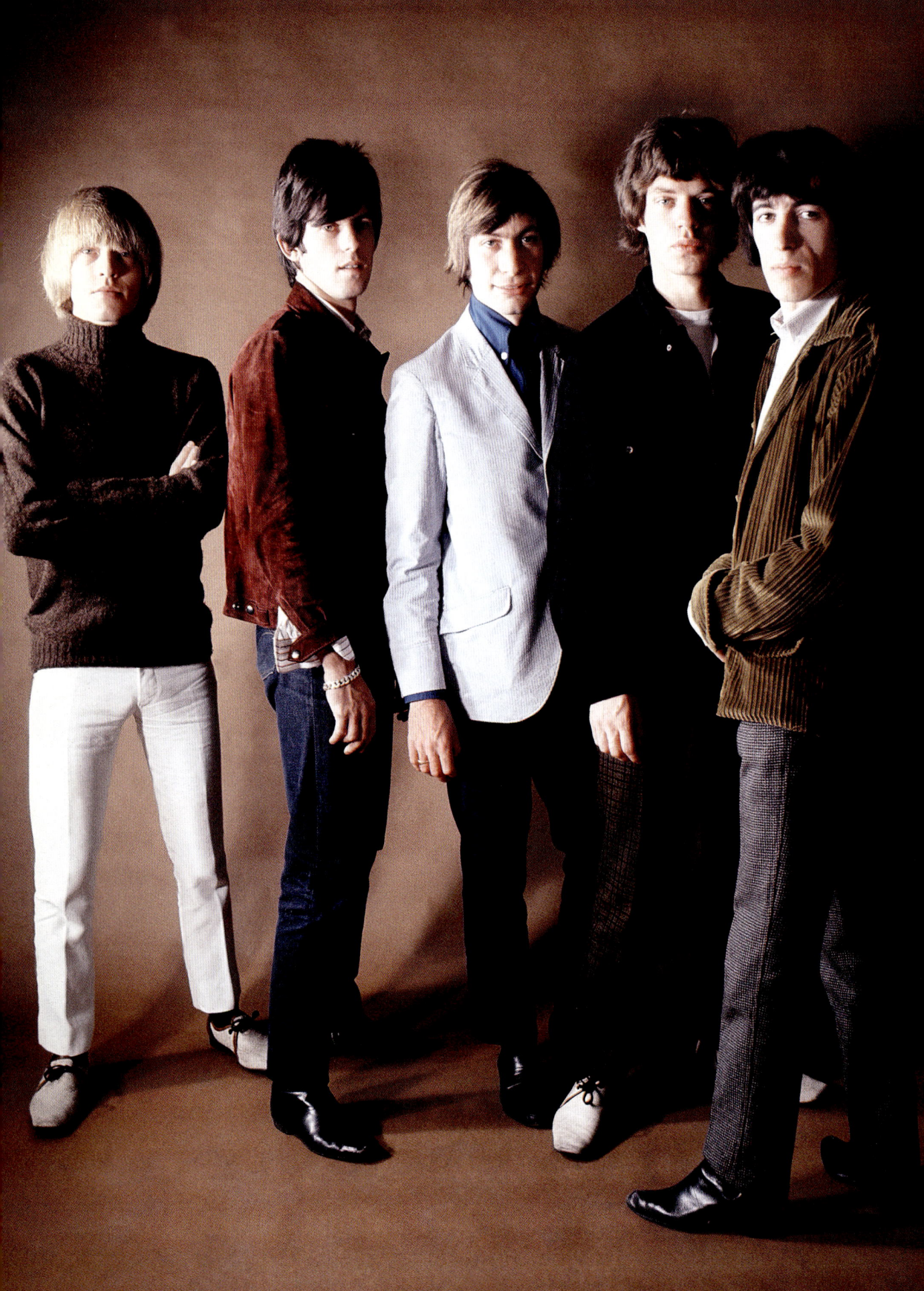

For many years, this was the only surviving colour photograph from the Mason's Yard session. As a result it's become quite well known, simply because it's all I had, and so I used it every chance I got. But I was able to recover the two on the following page quite recently, and they show perfectly the value of this deeper dive into my archive. The image opposite was the one chosen at the time. The band are all looking at the camera; it's a clean, sharp shot. But the ones on the pages that follow – both the colour photographs overleaf and the black-and-white images that follow the contact sheet later on – are really nice shots. The blur of Mick's face, Charlie looking at Bill; these things were enough for the photographs to be dismissed first time around, but looking at them now I realize that they aren't second-string pictures, they're little gems that have simply not been seen.

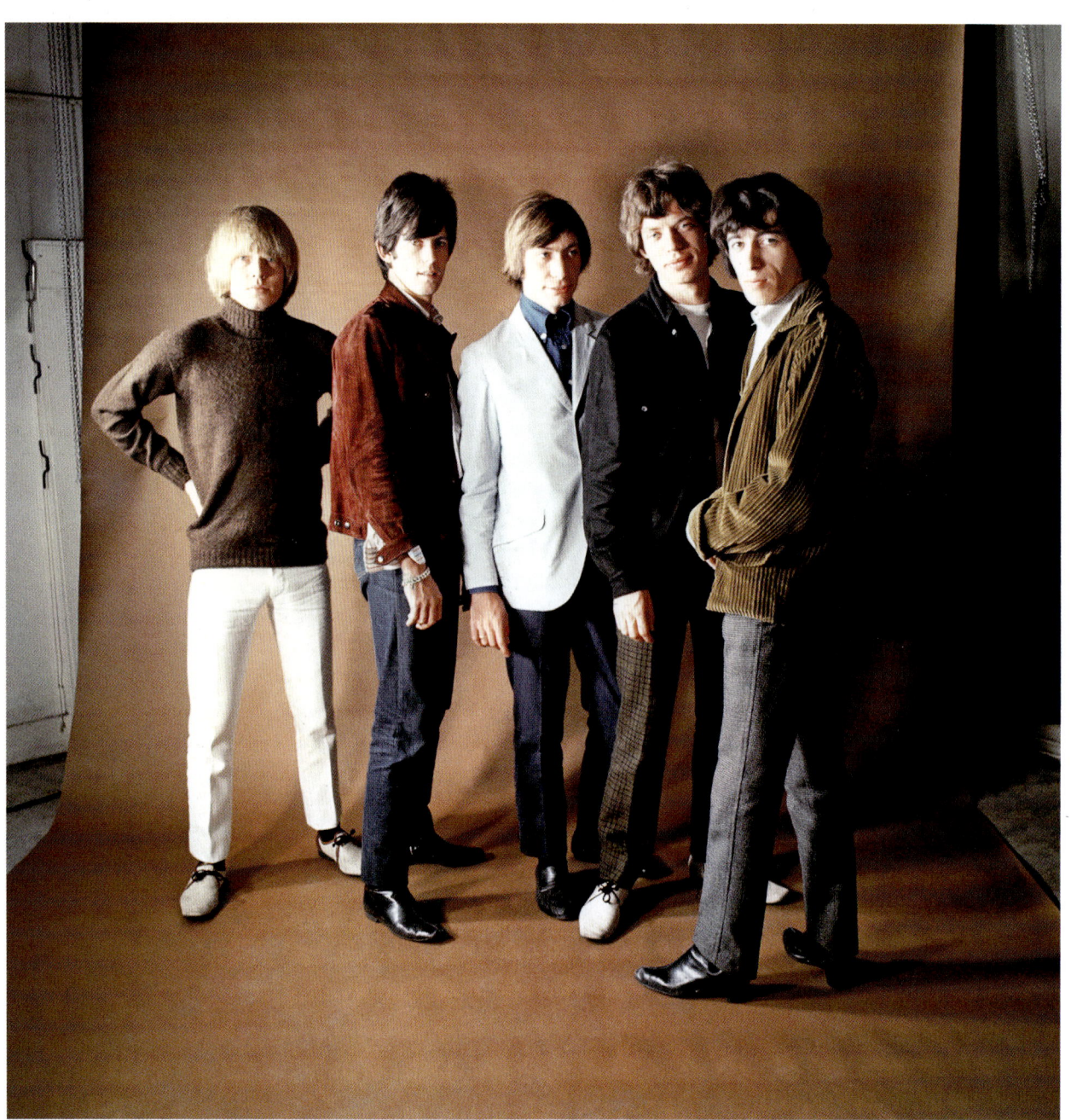

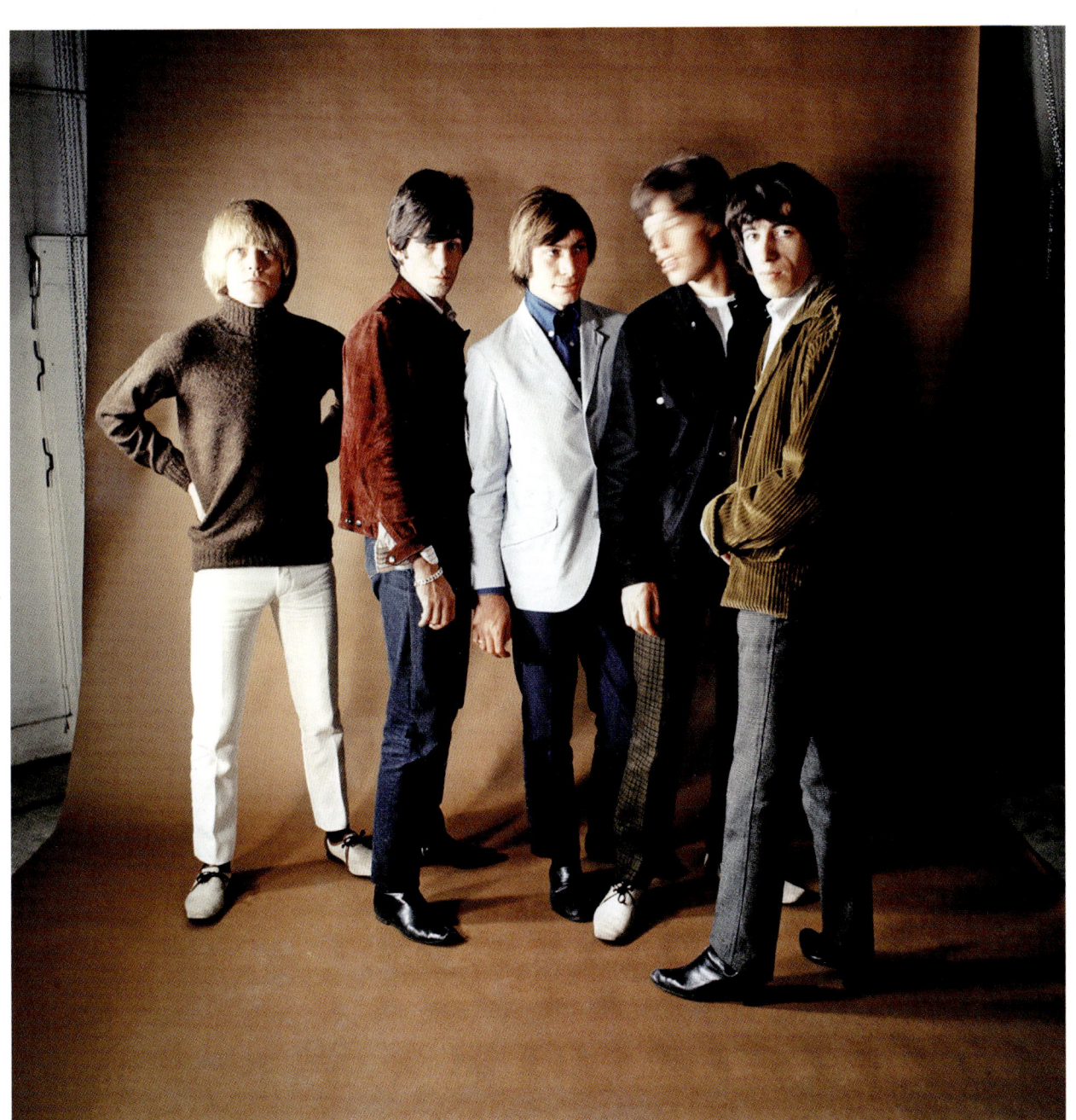

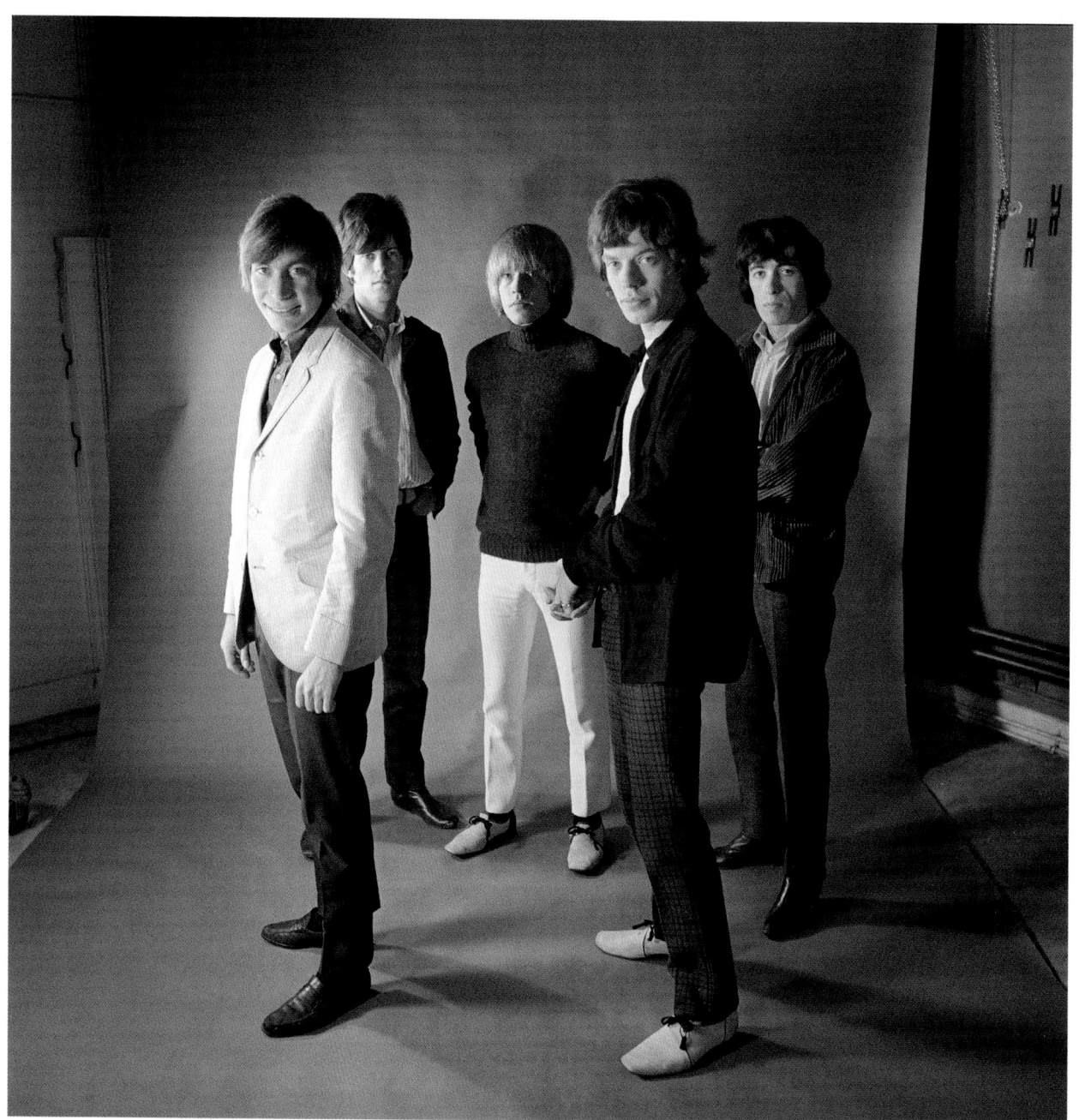

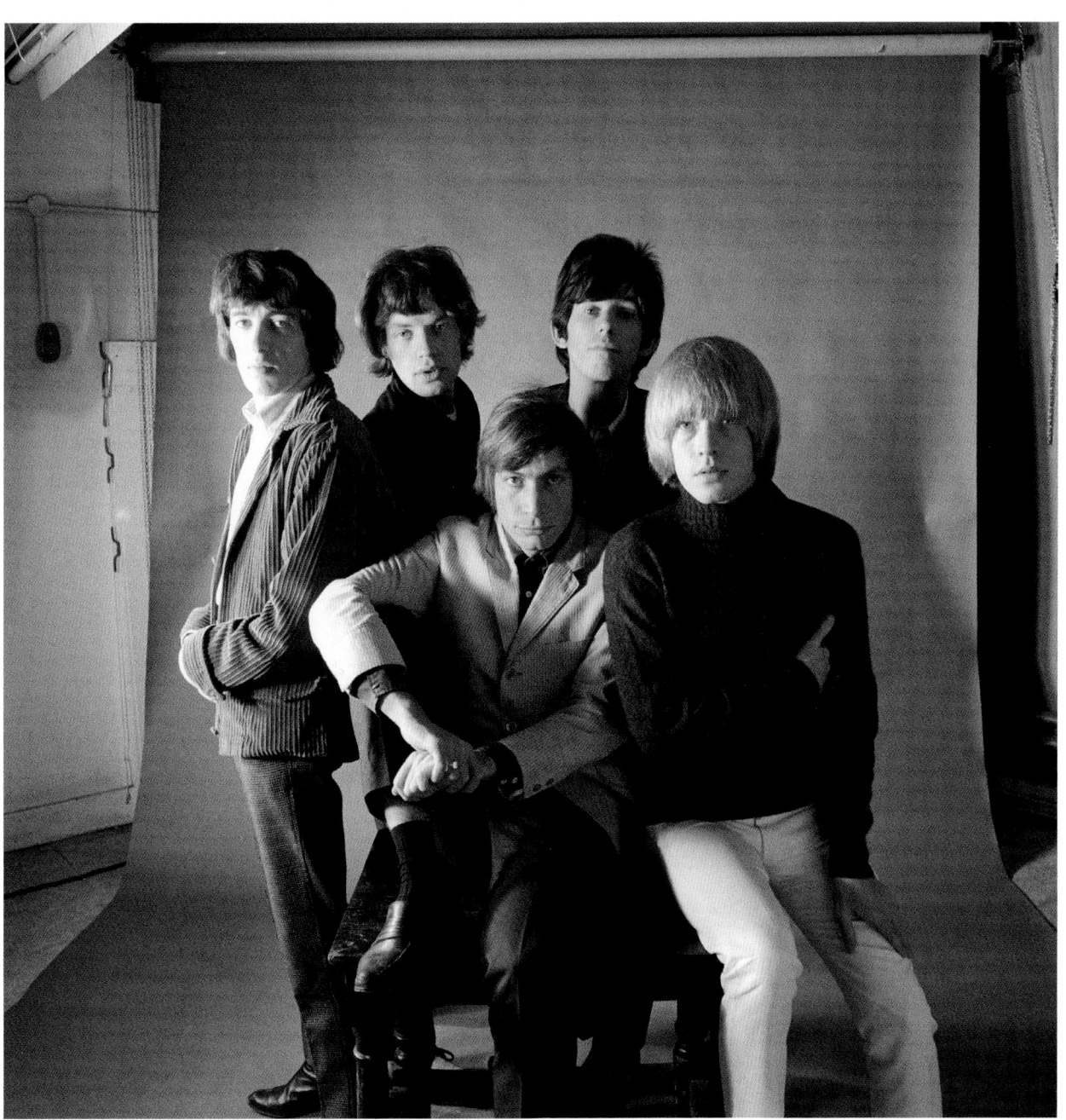

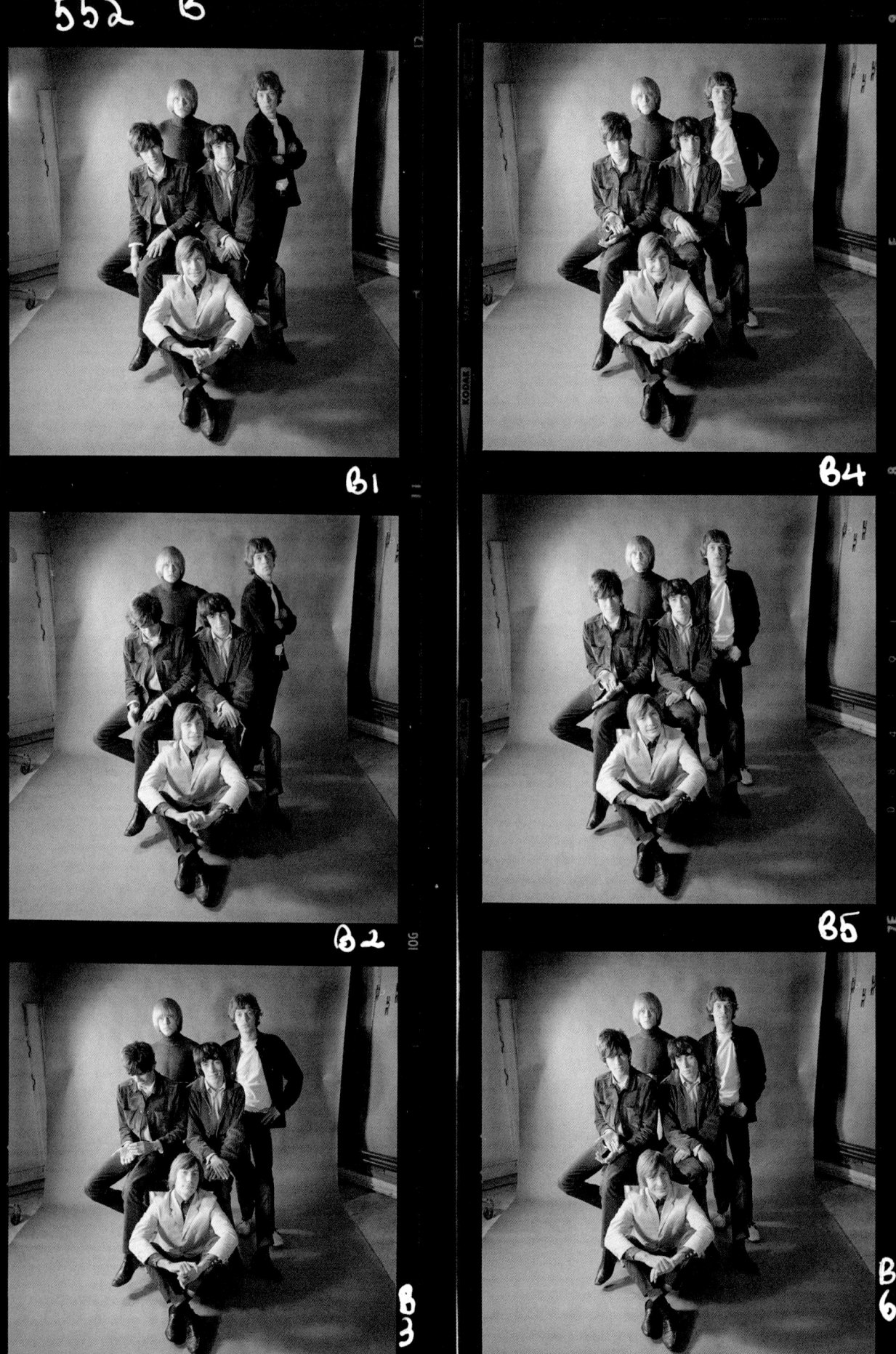

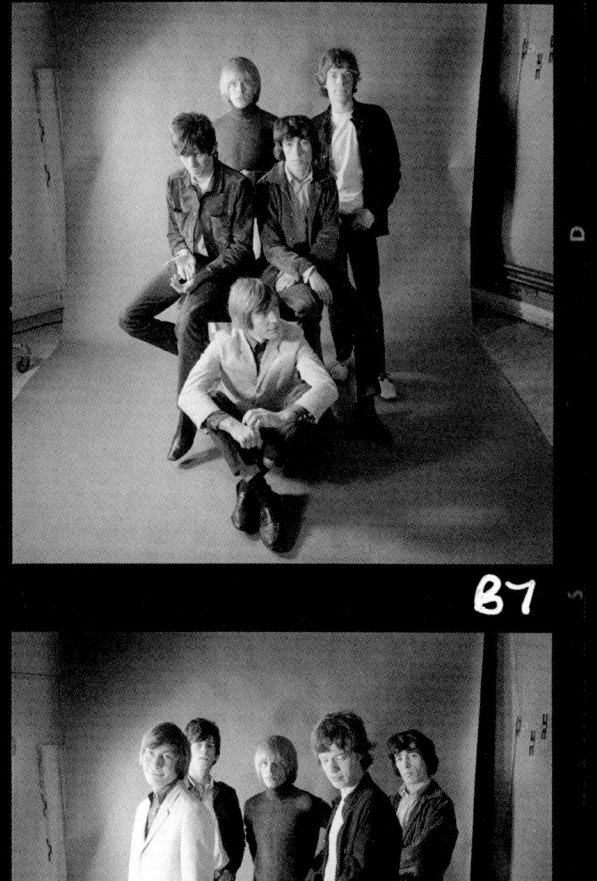
B7

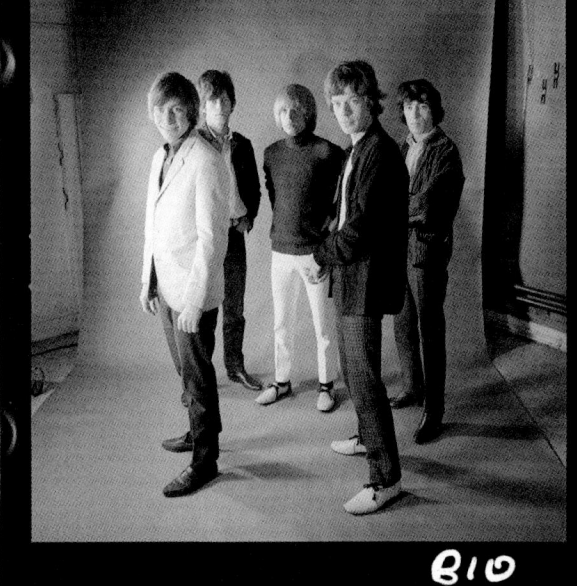
B10

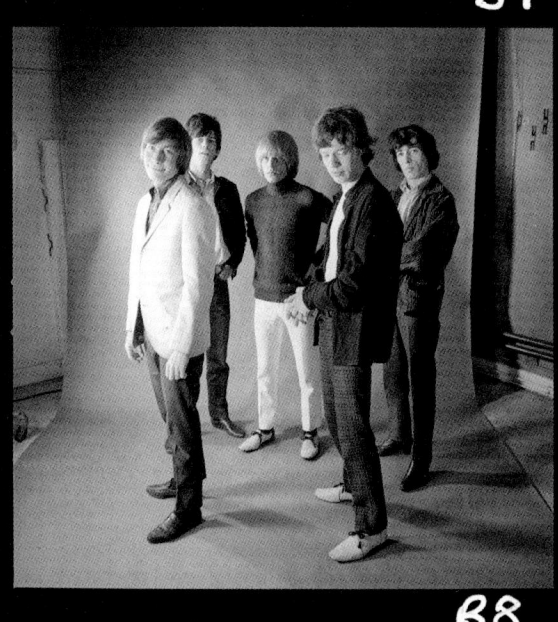
B8

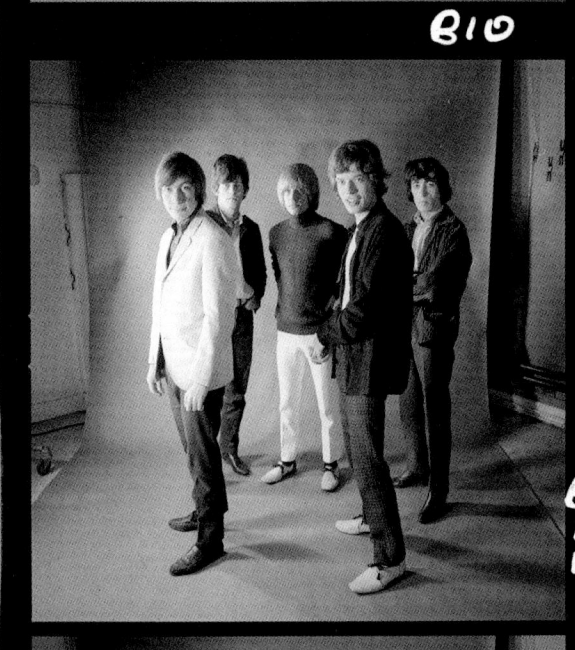
B11

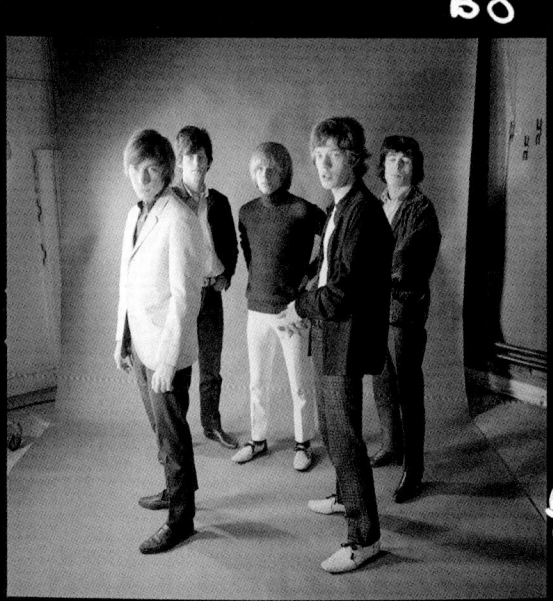
B9

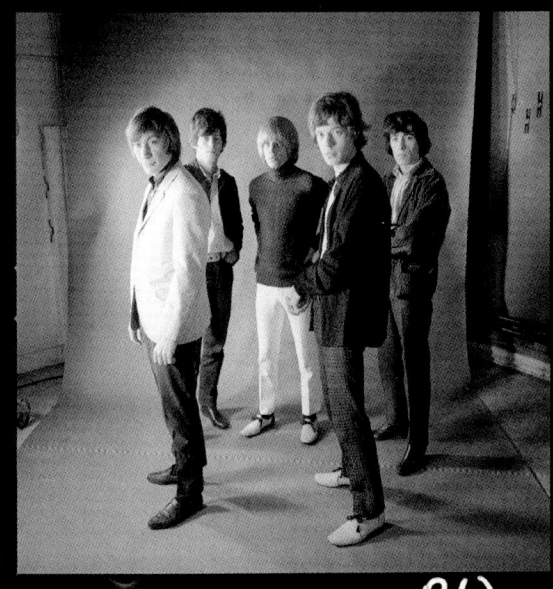
B12

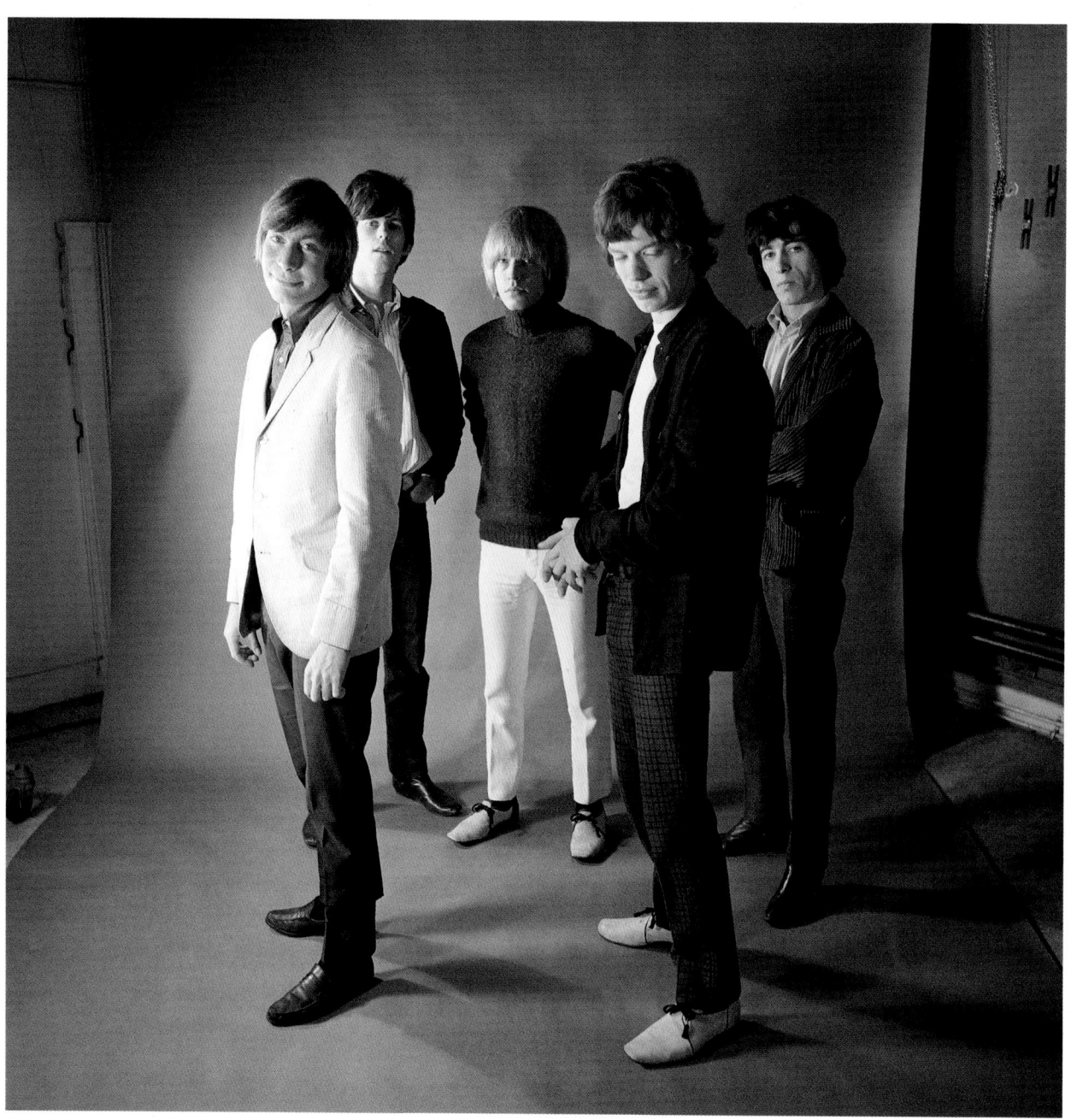

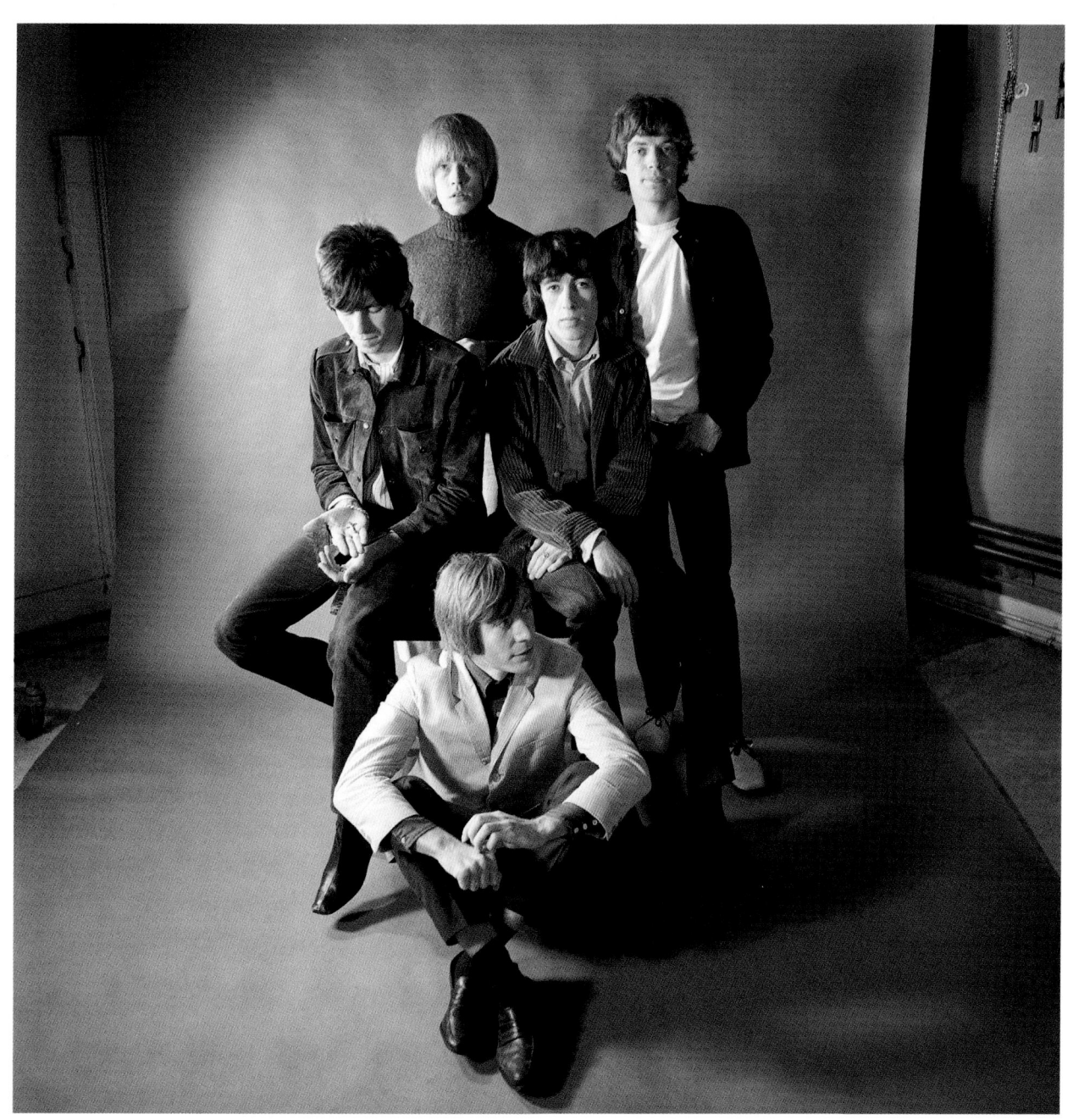

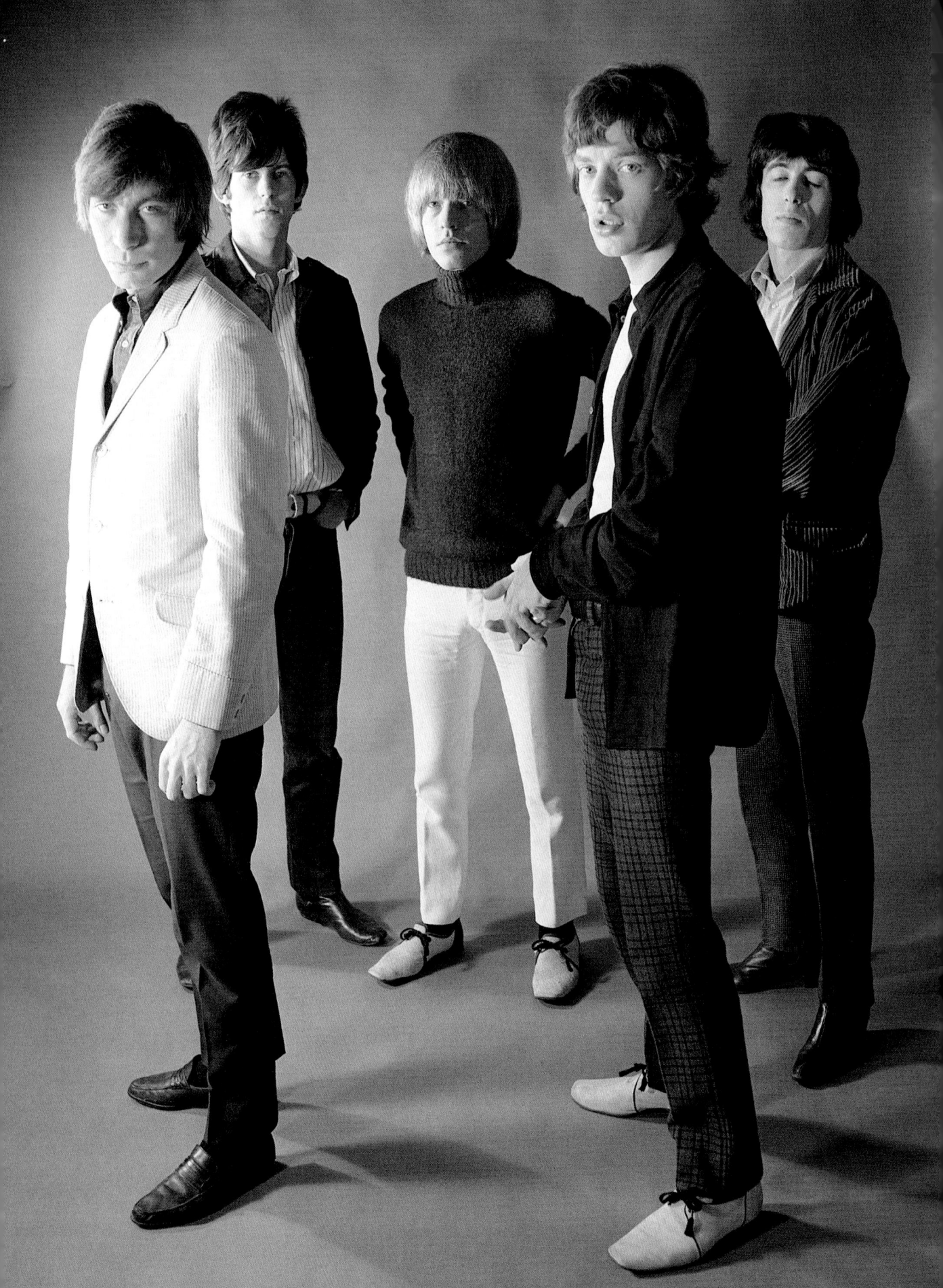

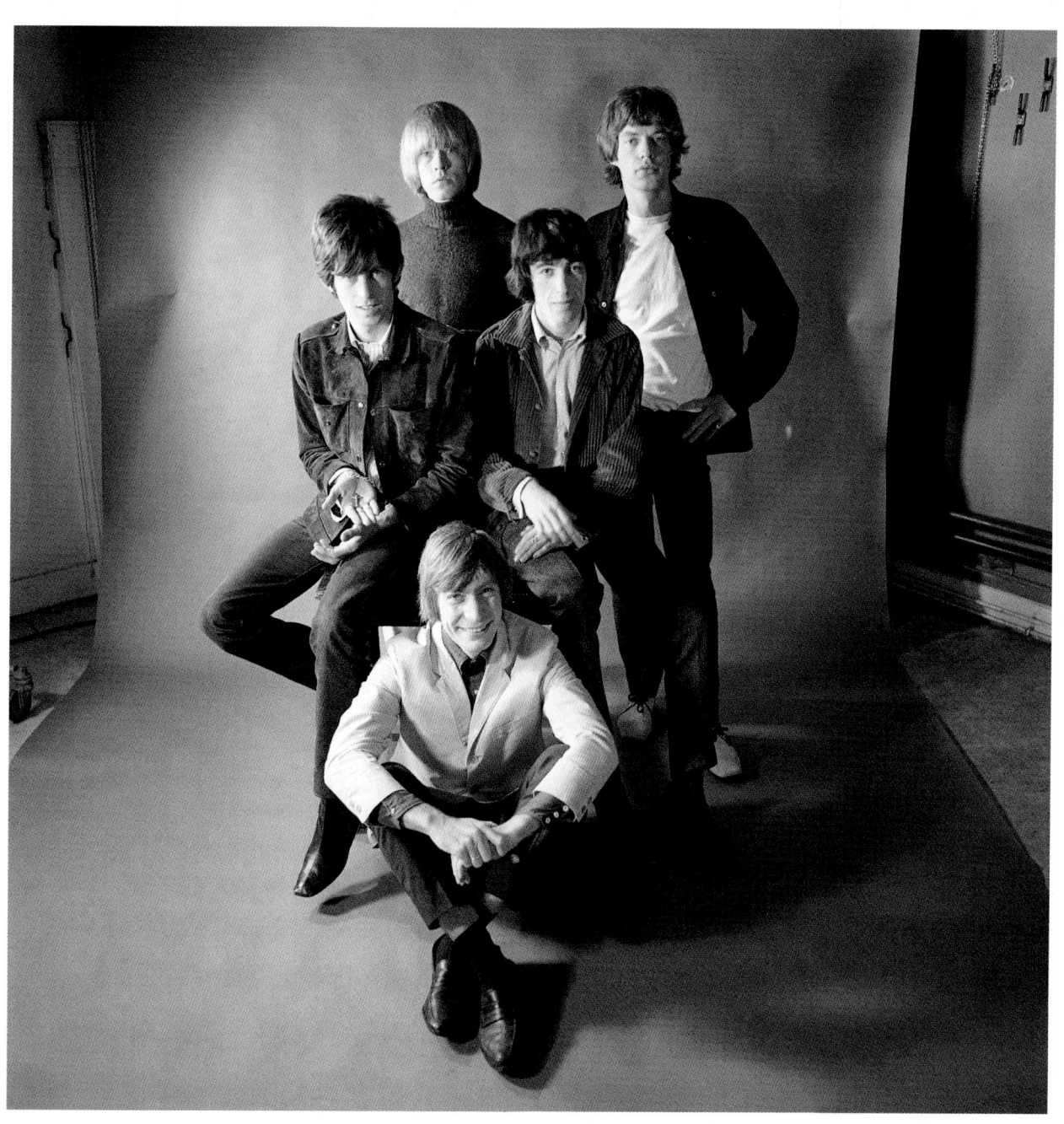

MASON'S YARD

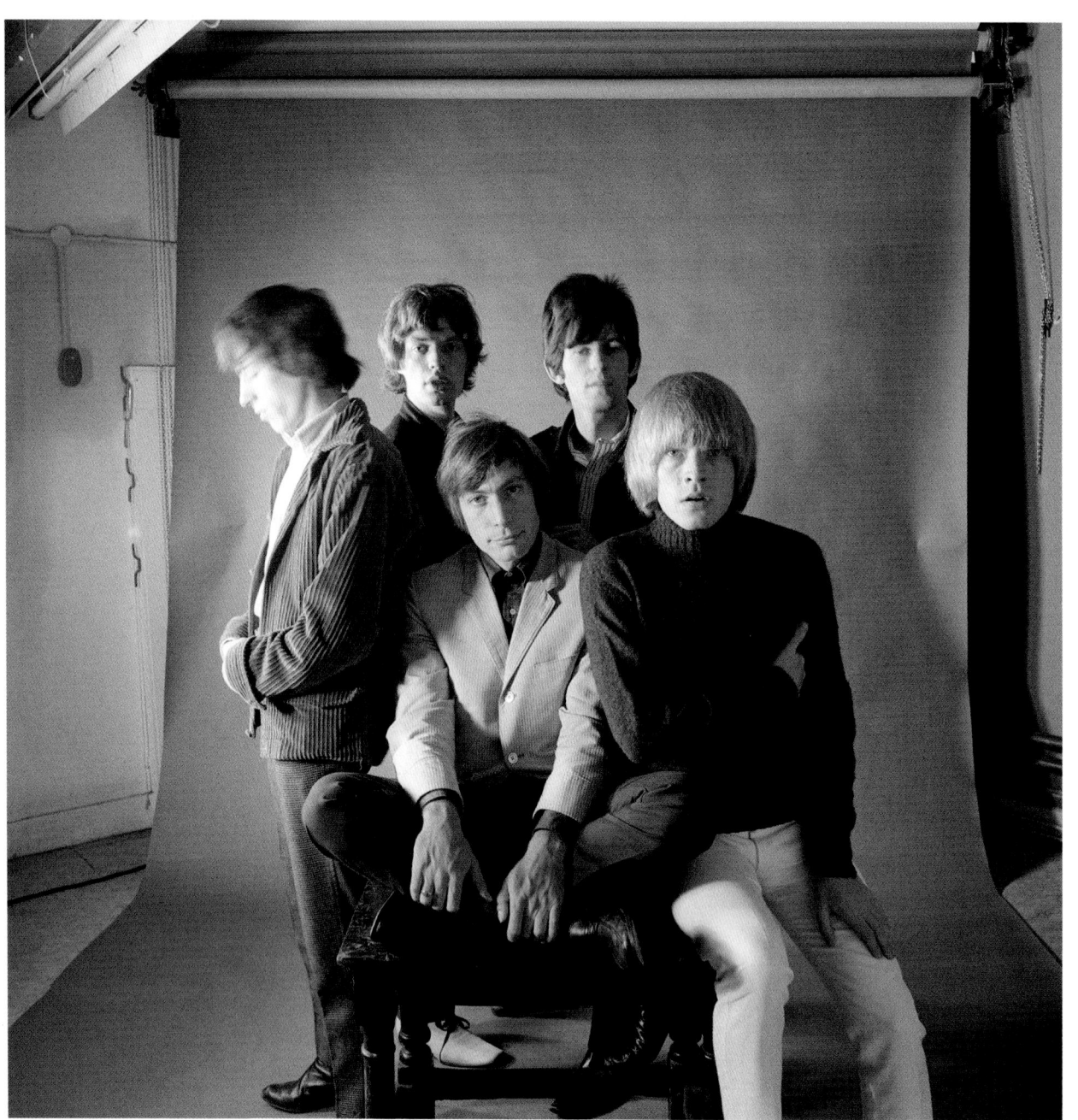

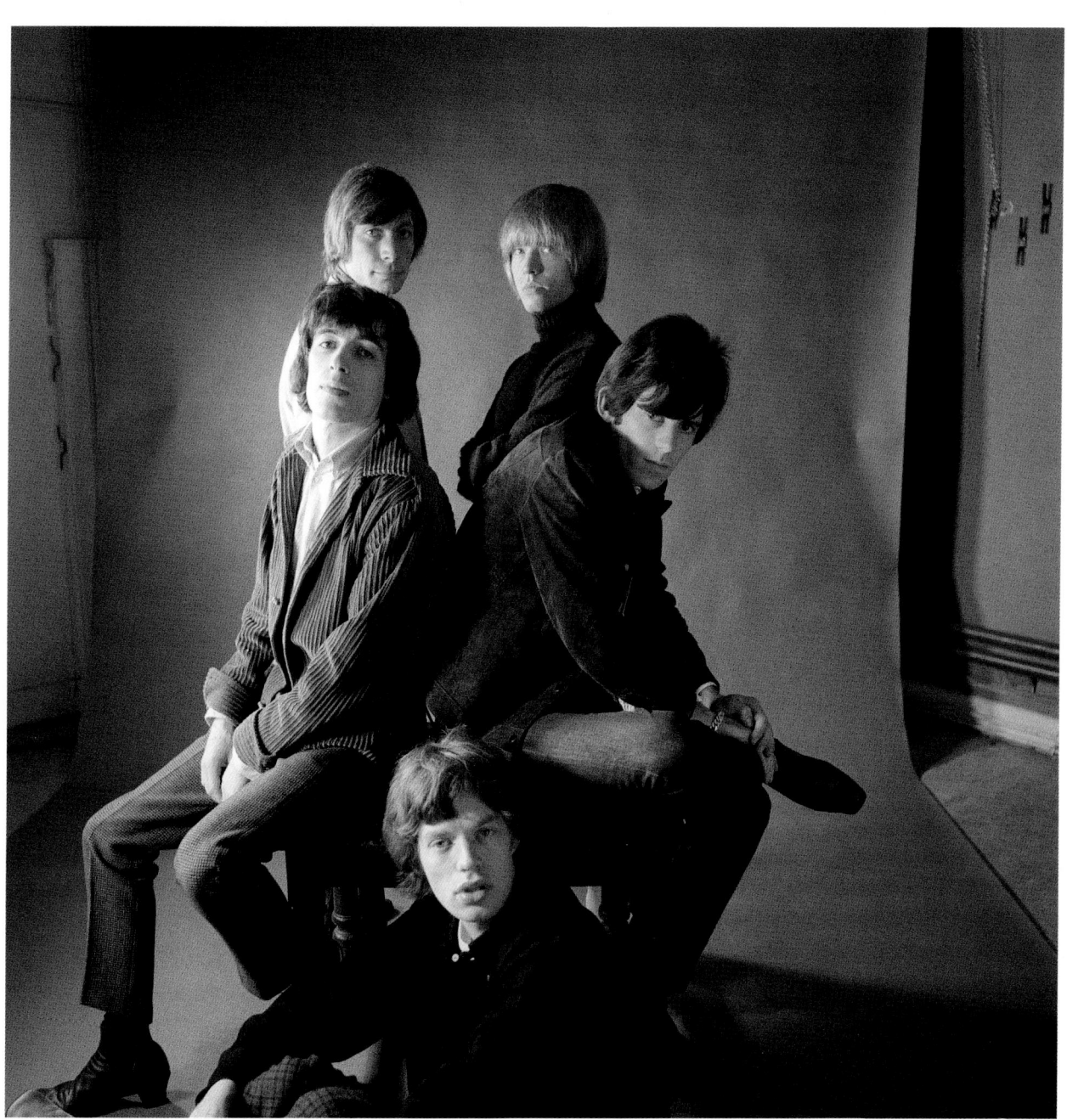

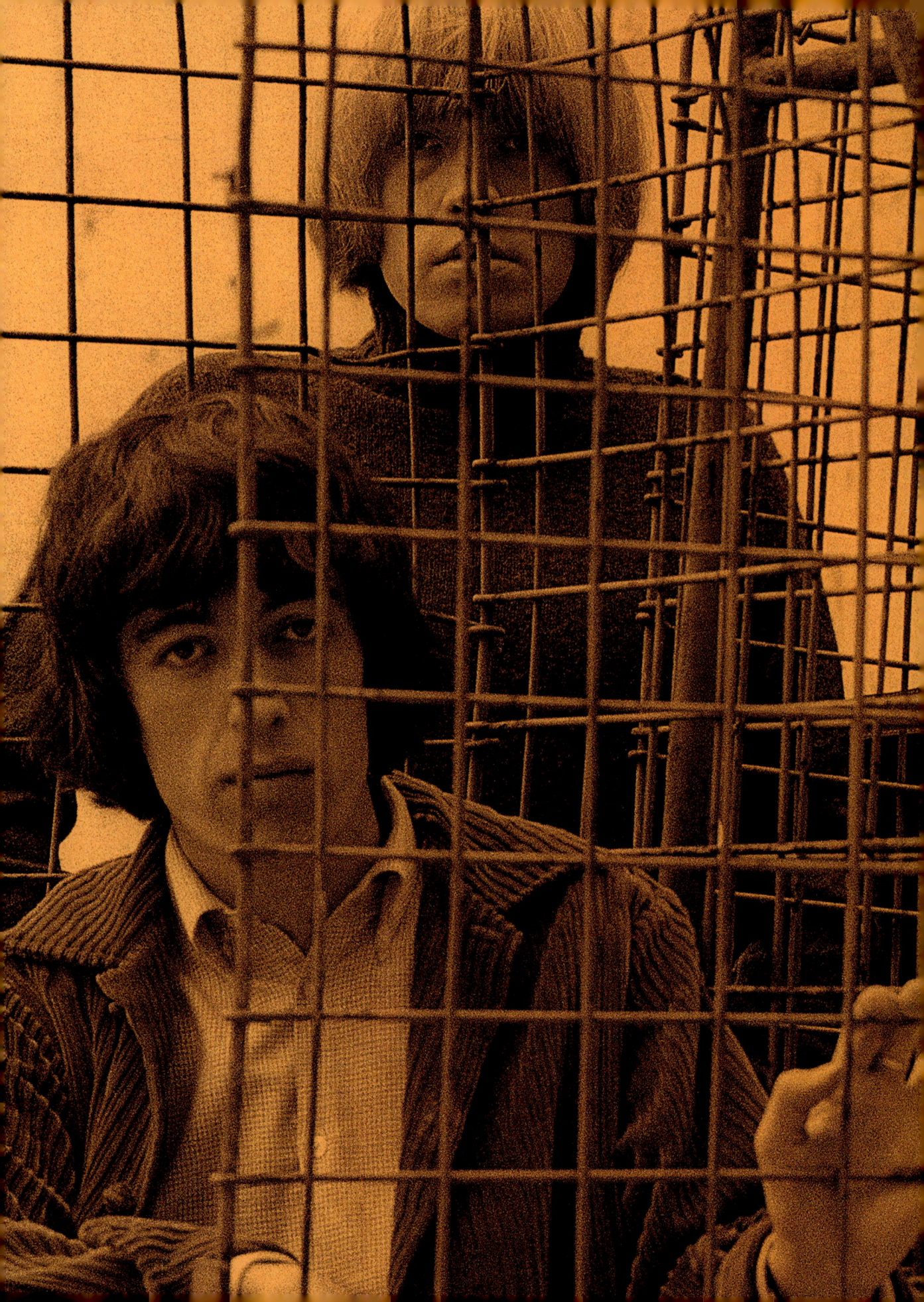

The previous pages show an iconic "caged" picture of the band, followed by an outtake from that same sequence. The photograph opposite shows the context of that shot. I originally had reservations about showing Brian in this slightly mischievous, almost boy-like pose, but looking back I think it's really rather interesting. In the background of this image you can see the two boards that I used for the famous photograph that would become the cover of *Out of Our Heads*. I squeezed the band in at the other end and shot through the boards to get the effect I wanted.

A well-known image of the group looking fantastic. Brian's smile is particularly infectious. But I love the picture a little later on, of all of them sitting on the wall with Keith looking down and Brian looking off to one side. I don't believe it's ever been published. I can see why not – I was originally trying to choose photographs where the guys all looked good and were all looking right at me. And so this shot, and others like it, were simply dismissed.

MASON'S YARD

At the end of the session I thought I'd finished, but Andrew stepped in and asked me to quickly "knock off" some passport pictures for the band – they were needed for visas and other paperwork for their upcoming tour. I went into a complete tailspin of panic. The pictures had to conform, the proportions had to be right, they had to look a very particular way. But I managed to get a few taken and – though there were the inevitable blinks, blurred eyes and laughter in some – I think all but Bill's were used.

out of
our heads
THE
ROLLING
STONES*

DECCA

The day after the Mason's Yard shoot, I nervously delivered contact proofs of the session to Andrew and awaited his response. He loved the session and my careful composition paid off because one of the shots became the cover of the next album, *Out of Our Heads* (or *December's Children (And Everybody's)*, as it's known in the US). On top of this, the shoot yielded single covers, posters and adverts as well as numerous press and promotional images, giving Andrew and his team a stock of images that would continue to be used throughout that year. It kicked off a long and fruitful partnership between the Stones and me.

The Sound of the Stones
Will Hodgkinson

History has decreed the Beatles to be the band against which all others are judged. They had the melodic sophistication, the lyrical charm, the unerring ability to push the life of the mid- to late twentieth century into new worlds. When you look at Gered Mankowitz's photographs of the Rolling Stones from 1965 to 1967, however, you cannot help but think: *this* is the band you would want to read about, go and see, and even, in your more fanciful moments, imagine hanging out with. It is the Stones, not the Beatles, who had an organic and unfettered quality that made them absolutely compelling.

What an excitingly spontaneous and imperfect force the Stones were. They came with a deep love and knowledge of American blues, soul and rock 'n' roll, which, coupled with a distinctly English unfriendliness, was powerful enough to kill off the early '60s jazz boom. "We discover we've stabbed Dixieland jazz to death," said Keith Richards, on the impact of early Stones gigs at the Crawdaddy Club in the Station Hotel, Richmond. Add to this that Mick Jagger, Keith Richards, Brian Jones, Charlie Watts and Bill Wyman had the kind of young men's faces – innocent but weathered, cynical – which could only have been carved from a post-war diet of rationing, outside baths and sadistic schoolmasters, and the elements were there for the Stones to upset the Establishment simply by existing. Something about their very being called into question the foundations of British society. They built a huge wall between their generation and the one that came before and they did it not with violence or revolution, but with music.

Mankowitz's photography belongs to a period of the Rolling Stones shaped by Andrew Loog Oldham, a brilliant, manic hustler who, inspired by Tony Curtis's desperate press agent in the 1957 film *Sweet Smell of Success*, saw in the Rolling Stones his chance to manipulate and titillate the British media and, through that, the public at large. Oldham says he never tried to change the Stones, only take what was there and run with it. It was Oldham who came up with the famous headline "Would You Let Your Daughter Go With A Rolling Stone?", and who made the most of three band members relieving themselves against a garage door in Romford one night. "We piss anywhere, man," Mick Jagger was reported to have said, just as '(I Can't Get No) Satisfaction' needed a bit of accompanying outrage to hit the July 1965 No. 1 spot.

Oldham recognized Jagger and Richards, not the Stones' gifted but difficult original leader Brian Jones, as the real force of the group. He convinced Jagger and Richards to get over their purist blues man pride and write songs, in doing so turning the Stones into the first band to really straddle the two worlds that continue to dominate commercial music today: rock and pop.

Gered Mankowitz's photographs tell the story of that early creative journey. At 18, Mankowitz was a year younger than the already very young Oldham, and ideally

"get off of my cloud"
THE ROLLING STONES

produced by andrew loog oldham

45-9792
LONDON

placed to capture a unique time in British music. He had his own studio in Mason's Yard in Soho; his father Wolf wrote the script for *Expresso Bongo*, a satire on the music industry that Oldham loved; and he had just photographed the young manager's new discovery, an aristocratic beauty falling somewhere between ingénue and sex symbol named Marianne Faithfull. She needed a song to launch her career, so Oldham locked his newly appointed songwriting team in a kitchen – or so the story goes – and refused to let them out until they had something to show him. The result was 'As Time Goes By', a lamenting ballad that its authors thought was, according to Keith Richards in his memoir *Life*, "a terrible piece of tripe. We came out and played it to Andrew and he said, 'It's a hit'. We actually sold this stuff, and it actually made money."

At the time, the musical theatre composer Lionel Bart had written a song for Faithfull called 'I Don't Know How'. But it wasn't right for her voice or persona, which is when Oldham thought of 'As Time Goes By', laid down in demo

form with the help of the session guitarist Big Jim Sullivan and the drummer Clem Cattini. Oldham changed the title, not least because it had already been claimed by a famous song in the film *Casablanca*, cut a couple of the soppier verses, hired an orchestra and told Faithfull to sing close to the microphone to build a feeling of intimacy. The result was a No. 6 hit. What could be more damaging for the rebel bluesmen image the Stones were meant to be fostering than a sophisticated, sentimental ballad with shades of Françoise Hardy's doe-eyed Euro pop? Yet it had artistic validity, mixed with pop art plasticity, and it hinted at what Jagger and Richards were capable of.

What followed was a period of the Rolling Stones as a brilliant, clever, challenging pop band. It began with 1965's *Out of Our Heads* and ended with 1967's *Their Satanic Majesties Request*, the latter album stymied not so much by the common assumption that the Stones were making an inferior version of *Sergeant Pepper*, but by the growing realization that they had outgrown their relationship with Oldham, that Brian Jones was too lost and broken to make a meaningful contribution, and that they were about to enter a new phase as the louche and ragged greatest rock 'n' roll band in the world, which began with 1968's *Beggars Banquet* and continues to this day. Mankowitz's 1965–67 photographs document a period when they were still a uniquely British phenomenon, even in the US: exciting to teenagers, terrifying to adults, not yet big enough to cocoon themselves in a bubble of fame and money, still subject to the same greasy spoon breakfasts, interminable motorway journeys and everyday hassles as the rest of us.

Mankowitz's first sessions for the band were shot in and around his Mason's Yard studio in April 1965. An outtake from *Out of Our Heads* has them seemingly imprisoned in a cage, actually a metal crate for moving bricks around a building site, and Brian Jones still looks like the leader, a dandyish figure with a pudding bowl thatch of hair, a high polo neck, white trousers and the kind of shoes that rendered him incapable of any kind of manual labour. You could see *Out of Our Heads* as a transitional album. It has plenty of American soul and R & B cover versions but then also 'Satisfaction', with its pop art conceit: the equating of sexual frustration with the impossible demands of the consumer society.

It also featured the first of the Stones' "down with girls" songs; misogynistic by today's standards, but also the work of callow young men masking hurt feelings with bluster and bravado. 'Play with Fire' details, against an ominously slow beat and a baroque harpsichord, the downfall of a young woman who had the misfortune to come by Jagger's way. Revenge involves watching her tumble down society's ladder, the ultimate indignity in Britain: her mother was an heiress with a block in St John's Wood, but she lost it all and ended up having to get her kicks in working-class Stepney, not in moneyed Knightsbridge anymore. The British have always been totally obsessed with class. Jagger was no exception.

Pop has image at its heart – and in those Mason's Yard shots, Brian Jones was the Rolling

Stone with the most striking image of all. You wonder if that began to change in America. In December 1965, after a gruelling tour that saw, among other things, an old lady attack members of the Stones with her umbrella in a Southern hotel lobby after taking offence at the length of their hair, they repaired to RCA studios in Hollywood to begin work on *Aftermath*, which is arguably their "down with girls" masterpiece. "I was obviously in with the wrong group," commented Jagger of 'Stupid Girl', a garage rock rant inspired by the groupies the Stones met on tour and the terrible, embarrassing, unsatisfied, one-night stands that came out of it. 'Under My Thumb' is both a far superior song and infinitely more sinister, a boast in which Jagger claims to have got the upper hand of a shrewish, domineering woman variously described as a "squirmin' dog" and a "Siamese cat". It made ominous sense that 'Under My Thumb' would be the song the Stones played at Altamont Speedway in December 1969, when Hells Angels pummelled to death a young black fan named Meredith Hunter. It is a truly nasty number.

"What a drag it is getting old," sings Jagger, long before he had a chance to put it to the test, on 'Mother's Little Helper'. On face value it seems like another embittered portrait of women and their weaknesses, but you could look at it another way. Jagger was showing sympathy for frustrated housewives, given over to suburban mundanity and leaning on tranquillizers prescribed by doctors to get them through the day, just as the various members of the Stones would increasingly lean on drugs prescribed by pushers to get them through the boredom and exhaustion of touring. And that came a few months after the masterful '19th Nervous Breakdown', a Bo Diddley-style stomp about a girl who has it hard: a neglectful mother who owns a million dollars tax, a father whose only interest is perfecting ways of making sealing wax, old boyfriends who mess with her mind. But after taking Jagger on a trip, it turns out that this mentally fragile woman is perfectly capable of disarranging his mind too.

"The generation that had fought World War II and had created the post-war baby boom found the use of such drugs dangerous, and made it as illegal as possible," wrote Stanley Booth in *The True Adventures of the Rolling Stones*. "They knew in their calcium-deprived bones that you can't be too careful." They also seemed, if the 1967 police busts on Keith Richards, Mick Jagger and Brian Jones are anything to go by, to take personal affront at the idea of rich young men transmogrifying their minds in the name of adventure and pleasure. Looking at Mankowitz's photos in the At Home chapter, you have to wonder if a bit of jealousy was involved too. Still only 1966, and there's Jagger sitting cross-legged before a brand-new Aston Martin outside his Gloucester Place mews flat; Keith Richards acting the dissolute country gent by squatting on a misplaced toilet on the lawn of Redlands, a thatched cottage of which bucolic fantasies are made; a dapper Charlie Watts taking his wife Shirley for a ride on their horse in the garden of their house in Lewes, Sussex; Bill Wyman posing with an MG in front of his

smart, middle-class home in South London; and Brian Jones, the worst offender of all, dressed like a young lord amid the Moroccan rugs and phantasmagorical paintings of his London flat. How could they be allowed to get away with it?

The answer is, they couldn't. Jagger and Richards toughened up after a few blows from the hammer of the Establishment, responding to spurious charges after the Redlands drug bust of 1967 with the sound of prison doors clanging shut on 1967's 'We Love You', but Jones went to pieces. The photographs of Jones at the *Satanic Majesties* sessions capture a tragic figure, a bloated princeling alone at the keyboard. By 1968 he was forgoing recording sessions for the Stones' *Let It Bleed* to head off to Morocco and hang out with the Master Musicians of Joujouka, telling the papers, "I have a feeling my presence is not required". On the sessions he did turn up to, Jones found himself incapable of playing guitar after breaking his hand.

"What can I play?" he asked Jagger, having come into the studio to find Ry Cooder filling in on the mandolin part for 'Love in Vain', giving the old Robert Johnson blues standard the kind of exotic flourish a year earlier he would have been supplying himself. "I don't know," came

the reply. "What can you play?" In June 1969 he was out of the band. A month later he was dead.

Essentially, the story I feel Mankowitz has told, in his unseen photographs of the Rolling Stones, is the downfall of Brian Jones and the rise of Jagger–Richards – and it is as poignant and sad as it is captivating. The photographs also chart the remarkable transformation of the Rolling Stones, via the pop immediacy of 'Satisfaction', 'Lady Jane', 'Under My Thumb' and so many other three-minute gems, from an earthy blues band into the impenetrable rock 'n' rollers they became. With that in mind, I wanted to save my favourite Stones photo shoot by Mankowitz for last.

Between the Buttons doesn't get talked about as much as solid classics like *Beggars Banquet* or *Let It Bleed*, but it is the Stones album that captured the spirit of 1960s' London better than any other. 'Something Happened to Me Yesterday' is an accurate account of being knocked for a loop by LSD for the first time. 'Yesterday's Papers' is both a harmony-rich melodic gem and a particularly nasty "down with girls" song about Jagger's ex, the quintessential Swinging London model Chrissie Shrimpton. On the US version of the album, 'Let's Spend the Night Together' celebrated London's new mood of post-pill promiscuity, and Keith Richards' 'Ruby Tuesday' painted his former girlfriend Linda Keith as the ultimate flower child and free spirit. And the cover captures it all.

Mankowitz shot the *Between the Buttons* session at a horribly early hour of the morning on Primrose Hill, London in November 1966, using a Vaseline-smeared glass filter to evoke the hazy, druggy mood of the times. Brian Jones wasn't playing ball, hiding in his collar and looking like a malevolent goblin, while the rest of the band did their best to pose for the camera. Mankowitz was getting frustrated at having his shoot ruined by the Stones' most annoying, if stylish and gifted, member, but Oldham told him not to worry: just go with it, let Brian be Brian. The result encapsulates so much; not just Brian's increasing lack of power and alienation within the group, which saw him demoted to the role of a disruptive clown, but also the spirit of the band itself and the accompanying mood of the era. It says more about the Stones, where they came from and what they became, than any other photo session I can think of.

Almost six decades later, the Stones are still with us. But the images collected here evoke a long-gone scene of young men learning how to be in a world-famous group and discovering what has to be lost and gained along the way. Something about the Stones always went beyond show business, much more so than the Beatles, even when they were dressing up in dandy fashions and writing three-minute pop gems. That is what Gered Mankowitz shot, so brilliantly and so naturally.

Will Hodgkinson is a music journalist, author and presenter. Chief rock and pop critic for *The Times* newspaper, he has written for the *Guardian* and *Independent* and for *Mojo* and *Vogue* magazines.

Taking the States

1965

I started working on a regular basis with Andrew and was asked to join the Stones on their autumn US tour. The call was completely unexpected, the idea of a group taking their own photographer on tour far from the norm. I really had no idea what to expect but I was up for it – and the thought of my first trip to America being with what was, to me, the best band in the world was exciting beyond belief.

We met up at London Airport, where we were to travel first class on TWA to New York City – just the band, Ian Stewart (their roadie and the sixth Stone) and me. Arriving in NYC and being met by a pair of Cadillac limousines on the tarmac was an exciting moment, but our arrival at the hotel was even more extraordinary: our progress into the car park was hindered by crowds of screaming teenagers climbing all over the vehicles and slowly crushing the roofs with their weight.

But the reality of touring back then was badly organized and exhausting. We were on the road for seven weeks and we travelled through the night straight after each concert, eating supper on the plane and arriving at the next town four or five hours later, where we would be met and driven to a dreary motel in a deserted town. Up at lunchtime, a meal at a local diner and then to the theatre, where we would be holed up in dire dressing rooms with no facilities, do the show – then back to the plane and the next show. It was tiring – though, of course, it had its moments and we had a lot of fun.

I knew what I was doing in trying to tell a story with this well-known photograph, but it was one of those extraordinary coincidences that I simply happened upon. We were in the VIP lounge at London Airport, Mick reading the *Evening Standard* story about the Beatles receiving their MBEs from the Queen while a contemplative Charlie prepares to head off on a hard-working tour of the States. Charlie hated to leave Shirley so was looking rather downbeat, but the collage overleaf, of pictures that haven't been seen before, show a more relaxed atmosphere in reality. The images over the page shine a slightly different light on the Stones story, as Bill's wife and son make a rare appearance. We were all told at the time to play down the band's marriages, so while it makes for a lovely photograph now, it wasn't really to be seen at the time.

63

1965

TAKING THE STATES

The Rolling Stones were the No. 1 band in America at this moment in time, '(I Can't Get No) Satisfaction' having exploded earlier in the year. They didn't have the same degree of fan response of the Beatles perhaps, but they were enormously famous, and so looking back it's funny to see this outrageous band, one that offended polite society, sitting in first class, surrounded by "normal" people. And, of course, the smoking looks so odd to us now, but it's such a feature of the period.

1965

TAKING THE STATES

TWA
ROYAL
AMBASSADOR

1965

Almost every show on the tour was stopped at some point because the young fans were so worked up and the police and security at the venues just didn't know how to handle it. So invariably the curtain would fall and a real confrontation would erupt. I shot this bad-tempered discussion between security on one side, and Andrew, booking agent Jerry Brandt and promoter Pete Bennett on the other – Keith and Brian having their say too. Eventually things would calm down and the concert would go on, at which point Mick would immediately race to the front and scream: "Get off your seats!" at the crowd – and it would all begin again. This is the first time I've ever shared these fascinating photographs. I love the one on the following page, showing just how bad tempered this "discussion" was.

TAKING THE STATES

A rare day off on tour, spent in Denver, Colorado. Keith, Charlie, Ronnie Schneider and I decided on a whim to go riding. Keith and Charlie both rode and both had a passion for the mythology and history of the Old "Wild" West, so we went off and enjoyed some downtime with some horses and a few guys from the ranch looking after us. I took these photos, just snapshots really, and then on we went with the tour.

1965

TAKING THE STATES

On Stage

1965

The band's live shows were always exciting to me. Being on stage with the Rolling Stones when they played '(I Can't Get No) Satisfaction' and their current No. 1, 'Get Off of My Cloud', night after night was fantastic. The desperate attempts of the police and security to control the completely crazed, screaming young fans was endlessly entertaining, but the shows were almost always halted by some officious police or fire chief. A backstage negotiation would then take place to restart the show – and within minutes Mick had got the fans back on their feet and it was all chaos once more! We were often back on the plane before the audience realized that the band had left the venue.

 Photographically, it was a somewhat frustrating and not very fulfilling experience, because the lighting was invariably awful, and occasionally so bad that I couldn't actually get an exposure. I tried to capture the atmosphere of the performances and, when I could, the audience as well, but it was tricky. I used only the available light because the band all hated the effect of flash and were disconcerted when it went off in their faces, and the theatre's lighting technology was basic and crude with often only one or two spotlights, invariably on Mick. Every couple of weeks I sent a package of film back to London to have it processed and sent to Andrew but got no feedback from anyone and didn't actually know what came out and what didn't, so I really was working in the dark. I also had no sense of why I was shooting all this material and no idea if any of it was being – or would ever be – published.

The boys played a concert at Fort Worth, Texas – note the Confederate flags in the background. For some reason the stage was in the round, an island in a sea of enthusiastic fans, and there was no safe way of getting the Stones to the stage. Someone had the idea of getting an armoured truck, putting the band in the back and reversing it through the crowd to get them to where they needed to be, surrounded by police. It certainly added some drama.

ON STAGE

1965

ON STAGE

ON STAGE

The British Invasion
Ben Sisario

In the beginning, they were less invaders than stowaways. In 1964, when the Rolling Stones first toured America, they were but one of a gaggle of British rock groups riding the coat-tails of the Beatles, booked as much for their hair as for their sound. With few hits in the United States that year – only 'Time Is on My Side' cracked the Top 10 – the Stones' stock price was not terribly high. American radio listeners were more likely to encounter the Dave Clark Five, Manfred Mann or the Animals. On the road, the soon-to-be World's Greatest Rock 'n' Roll Band flailed in a way that is difficult to grasp in hindsight. Two performances at Carnegie Hall in New York, yes. But also sparsely attended shows in purgatorial way stations like Omaha and Excelsior, Minnesota. At the Detroit Olympia, the boys drew about a thousand people – to a venue with room for fifteen times as many.

It was not for lack of hype. *Vogue* magazine had run a full-page David Bailey portrait of Mick Jagger, looking studiously louche, with a caption that gushed over his "perverse, unsettling sex appeal".

Keith Richards, in his memoir *Life*, portrayed this phase of the band's career as one of frustration and embarrassment. "By the end of the first American tour, we thought we'd blown it in America," he wrote. "We'd been consigned to the status of medicine shows and circus freaks with long hair." Andrew Loog Oldham, the Stones' early manager, was blunter: "We didn't mean shit."

In America of 1964, the very concept of rock 'n' roll was defined, or rather redefined, by the Beatles. The nation was seduced by their grinning charm, by their flopping moptops, by the sense of fresh and inevitable cultural transformation that the Fab Four embodied. The grown-ups embraced them as perfect new lads-in-law, matching suits and all, while their daughters squealed in tickled ecstasy as Paul McCartney counted off 'I Saw Her Standing There' with…wait, did he just say: "one-two-three-*fuck*"?!

The Rolling Stones, on the other hand, presented themselves as a smug hipster gang whose major aim was showing off the influence of their imported record collections. Chuck Berry, Bo Diddley, Jimmy Reed, Willie Dixon, Slim Harpo: the Stones wore the songwriting credits from their first album as though they were tattoos. How these young men wielded their bona fides was also a clue to the personas they brought to the band. Brian Jones was the snobby blues purist, Richards the Berry-stanning riff fanatic. It speaks to Jones's fledgling status as pack leader that Jagger – then as now a reader of winds – initially waved the blues flag with him. "I hope they don't think we're a rock 'n' roll outfit," Mick said in a notorious 1962 press item, published just as the embryonic Rollin' Stones, pre-Charlie Watts and Bill Wyman, were emerging from Alexis Korner's Blues Incorporated jam sessions in London.

Something changed in 1965, the year that Gered Mankowitz accompanied the Stones on an American tour as the group's official photographer. The catalyst was songwriting. Jones was never much interested in it, and

until this point Jagger and Richards had been little more than dabblers, their work ('Tell Me (You're Coming Back)', 'Grown Up Wrong') good enough for LP filler but always outshone by covers. The impetus behind their turn to writing was prodding from Oldham, who had absorbed from Brian Epstein and Albert Grossman, Bob Dylan's manager, the value of an act controlling its own repertoire. (A peer of the band's, he had also grasped the importance of image to pop stardom: the more outrageous, flamboyant and memorable, the better.) According to a tale told by Richards – and disputed by Jagger – Oldham once sequestered the two in a kitchen until they emerged with a satisfactory composition. That turned out to be 'As Tears Go By'. To the boys, it was "a terrible piece of tripe", but Oldham heard the sound of coins ringing. When recorded by Marianne Faithfull, the tune went Top 10 and earned Mick and Keith their first real payday as songwriters. Yet

they hesitated to add it to the Stones' set list.

Two songs burst the dam: 'The Last Time', released as a US single in early 1965, and '(I Can't Get No) Satisfaction', which catapulted the band to global stardom that summer.

Those songs distilled the essence of the Rolling Stones as not just a sound but an attitude: a mix of pleasure worship, casual misogyny and a sneering subversion of showbiz itself. 'The Last Time' gave a taste of it – Mick whined, over Jones's jagged, hypnotically repetitive guitar part, about his muse not trying very hard to please him – but with 'Satisfaction' the band landed fully on its approach. Over Richards's buzzing-insect guitar lick and Watts's insistent, snare-smacking beat, Jagger rants in a near monotone about the inescapable discourse of modern bullshit (man on the radio, man on TV), his critique focused not on justice or truth but on the nuisance of an interruption in the narrator's mission to get his rocks off. The world is a charade, Jagger is telling us, and he implicitly invites the audience to join him in the only appropriate response: to scoff and move on to the next thrill. As a contribution to the so-called British Invasion, this was as important as any riff.

The "invasion" was jive from the start, though it has been chiselled irrevocably into rock's historical mythos. In Anglo-American context, the term cheekily implies recolonization – a retaking, with guitars and "yeah yeah yeahs", of what had been lost on the battlefield generations before. But of course the 1960s' rush of British rock bands was just one more instance of the kind of cross-cultural wave interference that had been rolling back and forth over the pond for ages. In the recent past were Black American jazz musicians who had headed to Europe for bread and respect. About a hundred years earlier, the young rebel nation had freely pilfered anthems from the songbooks of its former masters. 'God Save the King' became 'My Country, 'Tis of Thee'. And a strange poem consisting of a series of protracted questions ("O say, can you see...?") was grafted to an eighteenth-century English tavern banger called 'To Anacreon in Heaven', thus yielding 'The Star-Spangled Banner', as heard in school halls and sports stadiums ever since.

The British groups that sailed triumphantly into Ed Sullivan Harbor did so not to reconquer, but because they needed America – its audience, its radio stations, its record sales and, certainly not least, its media infrastructure. Likewise the Yankee music business, knowingly or not, also needed the Brits to help shake off the last vestiges of Tin Pan Alley, which had defined the American industry since Stephen Foster's day.

Part of the Beatles' gift to was to inform the rock 'n' roll audience of how it was expected to behave. In an anthropological sense, the group's function was to elicit a response, and the Beatlemania "invasion" arrived with clear instructions. News reports depicting hordes of screaming young females had reached American shores well before the band did. The film *A Hard Day's Night* dwells on this phenomenon in surprising depth, portraying not just the orgasmic convulsions of the crowds but also the media machinery

being employed to capture and disseminate that excitement: television cameras focus on young women's faces and bodies as they leap and cry, while calm men scan the fans' movements on control-room monitors, seeking the most effective clips to sell a story.

To these rites and rituals, the Rolling Stones provided the behavioural model of a band. The Beatles, holed up in a studio on Olympus, were essentially inimitable. But the Stones made themselves the profane template for all rock groups thereafter – raggedly sexy, endlessly squabbling, avaricious, shameless, vain. "They look like boys whom any self-respecting mum would lock in the bathroom," wagged the *Daily Express* in 1964.

Their musical influence is evident from the countless shaggy-haired, "nuggets" groups of the mid-'60s, who carefully aped Stones guitar riffs in electrified garages from sea to shining sea. But riffs were only part of it. With some clever planning from Oldham – not much encouragement was needed – the Stones ably took on the role of the bad boys, the rakish villains. It was not all fiction, but not all fact either. In the early days, while the band shared a putrid Chelsea flat, they concocted one stunt after another to gin up spicy headlines from their conspirators on Fleet Street. Richards recalled one scheme for the guys to be ejected from the Grand Hotel in Bristol for inappropriate dress – with photographers duly tipped off to record the incident. "The media were so easy to manipulate," he wrote, "we could do anything we wanted."

"The Beatles looked like they were in show business, and that was the important thing," Oldham once remarked. "And the important thing for the Rolling Stones was to look as if they were not."

The Stones mocked the farce of showbiz even as they participated in it, profited from it. Applying some of the 1950s James Dean–Marlon Brando rebel sheen to the pop game, the Stones established a PR blueprint for every punk, metalhead or gangsta rapper down the road to flash their middle finger while dutifully posing for the cameras. For the Stones, at least, it couldn't really be called hypocrisy because the contradiction was the point.

Mankowitz's tour photos from 1965 capture the glory as well as the drudgery of their carnival. Charlie Watts peeing into a backstage sink. An extremely unathletic and confused-looking Bill Wyman clutching a basketball. Airport lounge boredom as they leaf through a newspaper puff piece headlined "A crowded day for the Beatles". And sparks onstage as Jagger spins within a spotlight's glow, separated from hundreds of cheering youngsters by a mirthless phalanx of uniformed police officers.

The success of 'Satisfaction', which went to No. 1 in the US that July, divided the year in two. Before that demarcation point, they could have been Herman's Hermits. (In fact, the Stones once shared a stage with the Hermits, and quarrelled with Peter Noone over headline billing.) A quaint press report from a concert that May in Long Beach, California, noted that giddy fans had lobbed jelly beans at England's newest hitmakers. By the fall, there was a riot at a concert in Rochester, New York, and the cops

pulled the plug after just six songs. Andrew Oldham could not have scripted better publicity.

Film clips from this period illustrate how the Stones' style took shape mid-invasion. Performing 'The Last Time' on *The Ed Sullivan Show* in May 1965, they sport unkempt hair, mismatched jackets and collared shirts buttoned to the neck. Jagger has not perfected his slithering strut, but his smirk is down cold. Richards is still the guitar nerd, grinning goofily when he whips off a perfect Chuck Berry-style solo, as though he knows he is getting away with something. During a performance of 'The Last Time' in the film *Charlie Is My Darling*, shot on tour in Ireland later that year, the heavy-lidded Jones turns and flashes a mischievous smile at the pandemonium beginning to stir in the crowd, delighted at the chaotic energy he has unleashed.

On the road, the boys were tourists in their own ways. Charlie Watts, already behaving like a vacationing pensioner, made pilgrimages to jazz clubs and purchased Civil War pistols, hats and various memorabilia. Ronnie Spector took Jagger and Richards for a baptism at the Apollo Theater in Harlem, where James Brown was performing. ("That's what made them so determined," Ronnie later recalled. "Those

guys went home and came back superstars.") Jones, growing ever more estranged from the band he once captained, met up with Bob Dylan and Robbie Robertson for a candlelit hotel room jam – unplugged and unrecorded – in the midst of the New York City blackout of November 1965. Bill Wyman, in his memoir *Stone Alone*, seems mainly interested in enumerating his many sexual affairs with young women. But to his credit, dour Wyman also was apparently the lone Stone to voice any scepticism over the arrival of Allen Klein, the wickedly effective business manager who soon took over from Oldham and ended up owning the rights to the Stones' entire 1960s catalogue.

'The Last Time', the first Stones hit composed by Jagger and Richards, was, like many great rock songs, borrowed without credit. The boys learned it from a Staple Singers' record from 1960, whose refrain "Maybe my last time, I don't know" was moaned over "Pops" Staples's tremolo electric guitar. But Pops didn't invent the tune, either. Its origins go back to a gospel standard with roots in the 1920s, if not earlier. For an art form in which the basic vocabulary is endlessly borrowed, recycled or outright stolen, originality resides in the authentic expression an artist brings to any new iteration. And no one could say the Glimmer Twins did not bring a novel message to 'The Last Time'. In gospel form, the song was a call to settle one's spiritual accounts before the reckoning that could come at any moment. From Jagger's lips, it is a petulant and purely carnal complaint to a girl: please me, or I will find someone else who will.

That misogyny – glimpsed on early covers like 'It's All Over Now' – was also a critical part of the early Stones' image, as Richards acknowledges in cataloguing what he calls the band's many "anti-girl" songs: 'Stupid Girl', 'Under My Thumb', 'That Girl Belongs to Yesterday', 'Out of Time', 'Yesterday's Papers' ("Who wants yesterday's papers?/ Who wants yesterday's girl?"). This despite the vital impact and inspiration that women like Faithfull and Anita Pallenberg had in shaping the Stones' artistry and style, as documented with wincing detail in Elizabeth Winder's recent book *Parachute Women*. It was Faithfull, for example, who offered Jagger his first proper literary diet; her suggestion to read Bulgakov's classic *The Master and Margarita* led to 'Sympathy for the Devil'.

In his memoir, Richards is no apologist for the band's portrayal and treatment of women. But he marvels at how young women responded to the music, stirring them to reject their moral programming, to embrace the physical pleasures they had been trained to deny. Rock could be an instrument of liberation as well as seduction. That was part of the invasion too.

"You realize what an awesome power you have unleashed," Richards wrote. "Everything they'd been brought up not to do, they could do at a rock-and-roll show."

Ben Sisario is a staff reporter at *The New York Times*, covering music, media and culture. His writing has appeared in *Rolling Stone*, *Spin* and the *Village Voice*, and he has taught at the Tisch School of the Arts at New York University.

Recording, Hollywood

1965

As the tour ended in Los Angeles in early December, the band headed into RCA Studios in Hollywood to record what would become the *Aftermath* album. Mick and Keith had been under a lot of pressure during the tour to write new material, so they would spend many evenings locked in their rooms writing, before finishing the songs off in the studio.

 I loved being in the recording studio with the band. Being completely non-musical I found the process magical, to be around the band as they developed the songs, watching and listening to them producing disparate sounds which, often quite suddenly, merged into a fully formed piece of music. You can feel the song emerging as everyone in the group starts to make their contribution, leading to this special moment where it just feels finished.

 Of course, I needed to keep out of the way when they were actually recording – there were microphones everywhere and I couldn't have a camera shutter going off – so I would stay in the studio with them as they worked on putting the songs together, before moving to the control room once they hit the red button. Often the best pictures were at moments of reflection, when the band were working something through or listening back to a track. There was a stillness and sense of contemplation that I found captivating. Being in the studio was a nice way of winding down after the tour before heading home for Christmas.

Keith and Bill working through parts in a song. I don't think they're recording here – I likely wouldn't have been in the room with them if they were – but rather are going through something new, with Bill finding his bass pattern. Just part of the magical process of the band making their music.

1965

1965

RECORDING, HOLLYWOOD

Laying the Blueprint
Dr Leah Kardos

The Rolling Stones burst onto the music scene in 1963 with their first single – a cover of 'Come On' by Chuck Berry – and quickly acquired a dangerous reputation. Riding the wave of the British Invasion in 1964, the group gained the attention of the press with their gritty sound, subversive image and upstart antics. They followed the wave to America in the wake of the Beatles, having been marketed as a long-haired, bad boy alternative to the Fab Four by their shrewd manager and producer Andrew Oldham, and attempted to conquer the singles market there. The success of the Beatles drove Oldham to insist that Mick Jagger and Keith Richards should try writing songs together. In the 2022 BBC documentary series *My Life as a Rolling Stone*, the pair reflected how the stunning success of their rivals had impacted their creative aspirations:

Richards: Our job was to be like the premier rhythm and blues band in London and we managed that. But we had no idea of progressing beyond that stage.

Jagger: Keith, he'd play the Beatles all the time. It'd drive me absolutely batty… Keith wanted to write these pop songs. We were undeniably the blues band, but we knew we had to be a pop band.

By now well-established in the US, the Stones released their third LP in America, *The Rolling Stones, Now!*. It came out in February 1965 and was primarily a compilation of material previously released in the UK, but it did contain a handful of Jagger–Richards compositions nestled among a selection of blues and R & B covers. While sounding rather imitative compared to what was soon to come, these early attempts showed promise, holding their own well enough next to Chuck Berry's 'You Can't Catch Me' and Willie Dixon's 'Little Red Rooster'. The original A/B side 'Heart of Stone'/'What a Shame' became their second Top 20 US hit in late 1964.

The band's emerging musical personality began to be more clearly defined with the release of *Out of Our Heads*, which shot to No. 1 in the US during the summer of 1965 and followed suit in the UK a few months later (though with a slightly different tracklist, as it was the norm at the time to leave singles off LPs for the UK market). The album's success was set up by the two singles that preceded its release. With its Phil Spector-assisted, Wall of Sound dynamics and a refrain borrowed from the Staple Singers, 'The Last Time' shot to the top of the charts in the UK and Europe, also cracking the Top 10 in America. Proof that the Jagger–Richards partnership had hit-making potential. But it was their next single, '(I Can't Get No) Satisfaction', that flipped the switch – in the words of Jagger, it transformed the group from "just another band into a huge monster".

A breakthrough hit with an unforgettable riff and a double negative in the title, '(I Can't Get No) Satisfaction' became the band's first US No. 1 single, their fourth in the UK. It was a track destined to remain the most recognizable Stones song ever produced, and one of the most enduring rock songs of all time. It started with a three-note hook and

a barebones idea for a refrain, hummed into a tape recorder in the middle of the night by a half-asleep Richards. The iconic riff that opens the track is played through a Gibson FZ-1 Fuzz Tone stomp box, a sizzling, scuzzed-up timbre that soon became associated with the sound of '60s rock 'n' roll, garage rock and psychedelia, influencing musicians from the Kinks, the Yardbirds and the Who, Jimi Hendrix and beyond. 'Satisfaction' was said to be responsible for a global shortage of FZ-1 units, as guitarists all over the world clamoured to ape Richards's scorched tone.

The inclusion of the effect wasn't intentional. Richards's idea was to replace the sound with a full brass section; the fuzzbox line was a placeholder. It's a good thing the band decided to keep it, since the riff rendered in brass would have only drawn more attention to the song's similarities to 'Nowhere to Run' by Martha and the Vandellas, which had come out a few months prior. The drum rhythms are also quite similar; both have a pounding snare decorated with tambourine that drives the energy forward, but Charlie Watts's pulse is much more aggressive and unrelenting, not so much sitting in the pocket as chomping at the bit. As Mike Edison puts it in his Watts biography *Sympathy for the Drummer: Why Charlie Watts Matters*, 'Satisfaction' was "a riff-basher of the highest order... in Mick's mouth, and in the hands of the Stones, it was the Big Bang, and Charlie Watts was at the centre of the event". Jagger's lyrics articulate a range of frustrations, from sexual to social, embodying the challenges of finding authenticity in a commercialized world. Rock critic Robert Christgau surmised the song in

US paper *Newsday* to be "the perfect Stones paradox," with "lyrics [that] denied what the music delivered". Jagger's vocals oscillate between carefully over-enunciated petulance in the verses and confrontational shouting in the choruses. A magic combination of scuzz, stomp and sneer that became the recipe for so much garage and punk rock to come.

1965 was an extremely busy year for the Stones, who had been managing their rising celebrity while trying to squeeze in the odd recording session around the gaps of no fewer than 11 separate tours that took them all around the world. The band's third US album of the year, *December's Children (and Everybody's)*, was designed to capitalize on their success in the wake of 'Satisfaction'. It contained a hodgepodge of unreleased recordings and covers but, like *Out of Our Heads*, it was primarily successful on the strength of its original cuts. 'Get Off of My Cloud' can be thought of as a companion piece and sequel to the anti-commercial smash that preceded it. Recorded at RCA Studios in Hollywood in September '65, the song was written as a response to the pressure they were under to turn out another quick hit. Richards later reflected, "After 'Satisfaction', we all thought, 'Wow, lucky for us. Now for a good rest...' And then in comes Andrew saying, 'Right, where's the next one?' Every eight weeks you had to come up with a red-hot song that said it all in about two minutes, 30 seconds."

The track is defiant and edgy, opening with a rude drum hook that feels like a slap to the face into a verse riff that recalls the Kingsmen's 'Louie Louie'. Bill Wyman's impatient bass seems to want to start a fight in the chorus, but the star of the show is Jagger's vocal, elevating the relatively mild lyric with a pissed off, borderline-hostile energy. Arriving a few months after John Lennon's plea for 'Help!', the aggression of 'Get Off of My Cloud' draws attention to the Stones' unique appeal during this period. An earthy, roughhouse alternative to the more family-friendly Fab Four, it confirmed Jagger as a compelling frontman.

Like the great composers who studied the masters that came before them, the Stones had educated themselves in how to create music with solid bones by covering, and stealing from, their musical heroes. From this assimilated wisdom emerged new creative confidence with 1966's *Aftermath*, the first Stones record comprised of all-original material. It was their first project recorded entirely in America, and in just one location – RCA Studios – which gave the overall album a sense of sonic cohesion. It was also the band's first project released in true stereo, allowing for separation of instrumental textures in the mix, resulting in their most polished and detailed sound to date. This enhanced sense of refinement can also be attributed to some inspired arrangement choices courtesy of multi-instrumentalist Brian Jones, the band's founder, who was seemingly adept at playing anything that could be found lying around the studio. Unusual textures like the sitar on 'Paint It Black', the marimba on 'Under My Thumb', the Appalachian dulcimer on 'Lady Jane' and the Japanese koto on 'Take It or Leave It' cracked open the Stones' aesthetic, allowing the band to wander beyond the boundaries of blues and R & B towards something more exotic and atmospheric.

This new sonic sophistication could be interpreted as a response to the increasingly cultivated sound of the Beatles, who had thrown down the gauntlet with *Rubber Soul* in late 1965, signalling a switch in industry focus from individual singles towards long-playing (LP) records. In 1966, the album experience emerged supreme with such scene-defining records as the Beach Boys' *Pet Sounds*, Bob Dylan's *Blonde on Blonde* (the most significant influence on pop songwriting for both the Beatles and Stones) and the Beatles' *Revolver*. *Aftermath* came first that year, its sessions yielding the group's third No. 1 hit in the US, 'Paint It Black'.

The song is a succession of two-part verses without a chorus – a sequence of repeating, hypnotic, undulating, melodic shapes and

sharp harmonic angles that somehow feel more exotic and modal than they are on paper (the song is mostly in F harmonic minor, nothing too outrageous). The raga-rock vibe is down to Jones's sitar embellishments, ghosted by Jagger's nasal droning, a quasi-mystic texture intensified by Watts's primal tom rhythms and Richards's Spanish-style strumming on acoustic guitar. The wriggly, serpentine bass part was performed by Wyman on the lower pedals of a Hammond organ. Jagger's lyrics draw the shades further on the already shadowy atmosphere, exploring themes of grief and depression. Legendary producer and arranger Tony Visconti (in fan mode, he wasn't involved with the production) once described the song as representative of 'a blanket worldview of desperation and desolation, with no hint of hope'. As the music builds towards its frantic coda, Jagger spits curses to blot out the sun, summoning an occult darkness that saturates the song with thick nihilism.

Between the Buttons was released in early 1967 and by this time the "concept" album was becoming popular as a medium, especially with music fans seeking a more altered and immersive listening experience. Studio techniques were evolving apace to facilitate this immersion. Multitrack tape recording allowed for more complex textures and combinations of sounds, with bands now exploring the potentials of layered performances. This was music that was only possible to create in the studio, straying further away from what would be possible to perform live. LCR stereo mixing allowed sounds to be positioned left, centre or right in the stereo field, putting the listener "inside" the songs. Spatial effects like reverb, echo and delay could create auditory illusions of space and size, moving the music away from the realms of physical reality and towards the fantastical and psychedelic.

Listening to *Between the Buttons* today, one can sense how the popular artists of the era were obviously paying close attention to each other. The shimmery organ of 'She Smiled Sweetly' and the tipsy vaudeville arrangement and semi-spoken vocal on 'Something Happened to Me Yesterday' feel influenced by *Blonde on Blonde*. 'Who's Been Sleeping Here?' sounds vaguely reminiscent of the Beatles' 'You've Got to Hide Your Love Away'. In turn, one can hear the influence of *Between the Buttons* on the Fabs' 1967 opus *Sgt. Pepper's Lonely Hearts Club Band*, particularly in the madcap music-hall sound of 'Cool, Calm & Collected' and the murky, drum-heavy production of 'My Obsession'. Of course, the Stones would soon be accused of directly copying the Beatles with their next LP, *Their Satanic Majesties Request*, which came out seven months after *Sgt. Pepper*. This was not only due to its similar musical and lyrical ideas, but also the colourful, otherworldly cover (shot by the same photographer, Michael Cooper).

Between the Buttons was met with positive critical consensus, yet despite the album's success, there aren't many songs from those sessions that are recognized by history as nailed-on Stones classics. The two exceptions are double A-side singles 'Ruby Tuesday', the baroque pop ballad that reached No. 3 in the UK and became the Stones' fourth US No. 1, and 'Let's Spend the Night Together', later covered by Bowie on his 1973 album *Aladdin Sane*.

'Ruby Tuesday' was written by Richards alone, in the wake of a devastating breakup with long-term girlfriend Linda Keith. The lyrics bid farewell to a free-spirited woman who Richards would later admit was "the one that first broke my heart". It shows a more vulnerable and tender side to the Stones, an aspect enhanced by a remarkably restrained instrumental arrangement led not by guitar but by Jones's delicately decorative recorder, sparingly underscored in the verses by emotive piano and cello.

The summer of 1967 famously became the Summer of Love, the moment when the press gave a name to the bohemian youth culture that had been growing since the mid-'60s. But for the Stones, 1967 was their most difficult year yet – sensationalized drug busts, gig riots, short stints in jail, the departure of Oldham and the

alarming deterioration of Brian Jones's health due to alcohol and drug abuse. And by the end of the year, they would self-produce and release their first flop, the sprawling, experimental acid trip of *Their Satanic Majesties Request*.

When it came out in December 1967, the album peaked at No. 3 in the UK and No. 2 in the US, despite being a critical disappointment. A popular opinion at the time was that *Satanic Majesties* was a pretentious misfire, a poorly conceived attempt at psychedelic rock that didn't stand up to contemporaneous efforts – not only *Sgt. Pepper*, but other tough competition like debuts from the Jimi Hendrix Experience (*Are You Experienced*) and Pink Floyd (*The Piper at the Gates of Dawn*). Some commentators took aim at the record's eccentric production values, like Richard Corliss of the *New York Times*, who described the musical arrangements as "ragged, fashionably monotonous and off-key". Chastened, the Rolling Stones corrected course back to blues-based rock the following year with *Beggars Banquet*, which was incredibly well-received and contained plenty of songs considered all-time classics, such as 'Sympathy for the Devil' and 'Street Fighting Man'.

Satanic Majesties remains a compelling curio in the Stones discography. Its ragged, undisciplined quality would have had something to do with the messy way the record came together: over eight months, without Oldham, on and off between scuffles with the law, and most of the time created under the influence of acid. Wyman would later describe the band's work ethic at the time: "Every day at the studio it was a lottery as to who would turn up and what – if any – positive contribution they would make when they did." These days the album has been largely reassessed and critically rehabilitated, not quite reclassified as a truly great Stones record, but certainly appreciated for its genuinely great moments. Tracks like 'Citadel' and '2000 Light Years from Home' rock out heavy with the kind of chunky psych riffage and space-age effects that Tame Impala's Kevin Parker would build his career on five decades later.

The standout cut 'She's a Rainbow' was released as a single a month before the album appeared. The song is flowery, sunny and sweet, with a luscious string arrangement courtesy of future Led Zeppelin bassist John Paul Jones, balanced by Brian Jones's celebratory mellotron fanfare. The distinctive piano part, performed by Nicky Hopkins, who played on dozens of Stones songs, is hyper-articulated from over-compression, gathering and framing the song within its ornate gilded edges. Childish "La La's" and playful fidgeting on violins and tambourine turn up the charm. Over time, the song has enjoyed a profitable renaissance in TV synchronization and advertising. Since the 2010s, it has been used in campaigns to promote Acura SUVs, Christian Dior fragrances, Sony TVs and Apple's iMacs.

The Stones rose to fame covering tracks by Black American blues and R & B artists, and over the years many Black musicians would repay the favour, with artists such as Otis Redding, Aretha Franklin, Etta James, Little Richard, Ike & Tina Turner and Prince recording notable covers. As they developed their own original sound, which blended blues and R & B with pop rock and psychedelia,

the Stones hit the peak of their commercial success: the whirlwind period between 1965 and '67 saw the Stones ascend to the top of the rock 'n' roll world order, with a string of breakthrough albums and hit singles.

Rock music of any variety today can trace its DNA back to this period. This was when the Stones laid out the blueprints for what would become hard rock, garage and punk – acts like Iggy and the Stooges, New York Dolls, the Black Crowes, Aerosmith, Jack White (the White Stripes), and too many more to mention, took key inspiration from this era in particular. Jagger's dynamic presence, bratty attitude, unvarnished vocal sound and androgynous image became the archetypal template for frontmen and women everywhere, from David Bowie, Steven Tyler, David Johansen (New York Dolls), Bobby Gillespie and Lenny Kravitz to Karen O, Harry Styles and Yves Tumor. The legacy of Richards's and Jones's innovative guitar riffs and layered arrangements would go on to influence the development of more complex evolutions of hard rock, heavy metal and post-punk. Jones helped the Stones expand the sonic possibilities of rock by introducing strange new instrumental colours to the palette – marimba, accordion, recorder, sitar, dulcimer, synthesizer, mellotron, koto. Like the Beatles had done for pop in the 1960s, the Stones also did for rock, elevating the genre to an art form: gruff, eloquent, dark and decadent.

Dr Leah Kardos is a composer, musician and author. Senior lecturer in music at Kingston University, London, she co-founded the Visconti Studio with legendary music producer Tony Visconti.

LEAH KARDOS

Stones At Home

1966

The Stones toured almost without a break for the first seven months of 1966 and although I saw them socially and briefly at the office now and again, we didn't actually shoot another session until the summer of that year, when it was decided for me to shoot an "at home" series with each of them in turn.

Money was beginning to flow to the band and they had all purchased new homes and nice cars. Their press office wanted to have photographs of the group in the new houses, but the band definitely didn't want their private spaces invaded by strangers. By this point we were good friends, so it was decided that I would produce the images.

I spent a day with each of them over the course of that summer, trying to put together a picture story of the Stones at home. It was a lot of fun and lovely to be able to hang out with the guys in such relaxed settings. They were all proud of their new homes, but they were also taking the piss out of that whole "at home" genre of celebrity portraits – Mick sitting in the bath, Keith posing on the toilet that was waiting to be installed, all of them having fun with some very silly, very knowing modelling.

As it happens, I have no memory of any of the photos being used at the time, but looking at them now they give a wonderful insight to an innocent, comfortable and completely lost time for the band.

Mick was between two homes when we shot this. Here, we were in the mews he was moving from, with cobbles outside. He's posing with his Aston Martin DB5, a beautiful car and a real status symbol of the time, and of course he was very proud of it – though he was not a great driver. There's a famous photograph somewhere of Mick on the street, talking to a policeman, with a great gash down the side of this same car.

STONES AT HOME

Keith's Redlands estate was very different from Mick's city pad, but he also had a status symbol car of his own. This is the Bentley he named Blue Lena, after the singer Lena Horne. It's the car that Keith, Brian and Anita Pallenberg famously took to Morocco. Again, we were having some fun here, Keith taking the piss out of the old "me and my car" portrait set-up.

STONES AT HOME

STONES AT HOME

Charlie's house in Lewes, Sussex, was very old and filled with antiques, which he was very fond of collecting. He once came back to my family home, where my dad – quite an antiques expert – had taken Charlie to a local shop and helped him to buy some furniture. He looks quite formal in many of the photos here, but really he was very laid-back and easy-going, breaking out every now and again into a slightly silly pose for a bit of fun.

STONES AT HOME

STONES AT HOME

1966

STONES AT HOME

Bill's home was quite distinct from those of the other Stones, because he was the only family man in the band. He owned what was really a smart, suburban middle class family home, though I was briefed not to show that side of it too much. The original idea had been to shoot a portrait of each member of the band in their cars – and you can see Bill here – but it didn't quite go to plan. Charlie didn't have a car at that point, so we had to make do with his and Shirley's horse, while Brian had been banned from driving. Plus, the day I went round to photograph him, his white Rolls-Royce was being looked after by his chauffeur.

1966

STONES AT HOME

1966

STONES AT HOME

For many, many years, the vast majority of images from this session were lost, and I had only a handful of colour photographs of Brian at his home near South Kensington in London. But I mentioned this to Bill recently, lamenting how much material had been lost down the years, and was delighted to hear that he thought he might have somehow ended up with something from this session himself. Lo and behold, he appeared sometime later with a black and white contact sheet, showing another dozen images from my time with Brian. They'd been packed away for fifty-odd years.

1966

STONES AT HOME

GMS 1136 A

A7

A10

A8

A11

A9

A12

This photograph is the sole surviving image from a session that was lost at the time, I've no idea how or why. I was left with nothing at all – in fact, I couldn't really remember a great deal about the shoot. But I was able to recover this frame, which was used on the back cover of the *Got Live If You Want It!* album. I'm so pleased I have it; it's a great shot that really echoes what the shoot was all about. I love how all of them look. Sometimes you get a photo where a band member perhaps doesn't shine quite as brightly as the others in the shot, but they're all at 100% here.

The Stones and Style
Terry Newman

"By 1966, Mick Jagger was the most wanted guest in the world, the final face, the ultimate. For one pout of his red lips, any millionairess hostess going would have promised away her life." So declared Nik Cohn in his rollercoaster read, *Awopbopaloobop Alopbamboom*. Cohn lived the '60s music and fashion scene, but the Rolling Stones defined it.

Their fame was transatlantic. When they arrived for their first tour in the USA, headlines infamously read, "Would You Let Your Daughter Marry a Rolling Stone?". They were a little wilder and cooler than anyone else and photographer Gered Mankowitz had a front-row, first-class seat, watching and shooting the band as they discovered the world, and the world discovered the group's style and sedition.

The Stone's manager, Andrew Loog Oldham, decided Mankowitz was to become "our man" after he saw his early portraits of Marianne Faithfull wearing knee socks and Mary Jane shoes sitting in Covent Garden's Salisbury Pub. He commissioned him to take the celebrated cover for the 1965 UK album *Out of Our Heads*, which shows the boys in modish full floppy fringe mode, staring insolently down the barrel of Mankowitz's lens. Oldham was 19 when he began looking after the Stones, and Mankowitz just 18 when he became an essential part of the band's entourage after being asked, following that legendary first cover session, to come aboard, travel and tour with them to America.

Youth was at the heart of fashion, art, music and culture during the '60s and its momentum changed society. This dizzying moment in time is mirrored in Mankowitz's images of the Rolling Stones, which have become a visual history of fashion. His pictures are not just a close-up of one of the biggest bands in the world, they also characterize the pop and style explosion that swept the globe in the Swinging Sixties – when British designers working out of boutiques in Carnaby Street and the King's Road were deconstructing the structural restraints of class and finding new energy inspired by the creativity of what was being worn on the street. Mick, Brian, Keith, Bill and Charlie were at the heart of it all, and helped lead the way.

The 1960s were a culmination of the emergence of teenagers and countercultural fashion of the 1950s when street style became a phenomenon in the UK and subsequently became a revolution that resonated around the world. Hipsters, jazz cats and Teddy boys and girls paved the way for a clear division between the generations in the 1960s. Young people didn't want to look like their parents and rebelled. It's easy to understand why the Stones, who personified youth, became a powerful metaphor for the decade, and although hierarchies of fashion were still well established by the time they hit the charts, it was a time of change. In 1966 Yves Saint Laurent launched Rive Gauche, the first ready-to-wear line in Paris, and a younger, more inclusive range – cheaper than traditional haute couture and in tune with trickle-up theory. Now, instead of the illustrious fashion houses dictating hemlines, they were

themselves influenced by counterculture: Saint Laurent produced collections in homage to bikers, beatniks and flea-market treasure – unheard of when duchesses and society ladies were used to holding sartorial sway. The Rolling Stones typified this trickle-up theory that defied the traditional Parisian dominance of fashion. The fashion industry is about trendsetting and what the Rolling Stones wore reflected not just stylistic changes but these cultural shifts too, and their fusion of music and fashion helped hyper-drive new ideas about what it meant to look good.

Fashion reveals identity and in Keith Richards's memoir he asserts: "you don't find a style. A style finds you." Mankowitz's shots show the Stones finding their style and the gradual evolution of becoming themselves. Mankowitz's imagery takes fans and fashionistas alike on a journey through the Rolling Stones's wardrobes – at a time when stylists weren't on the payroll and instead the clothes they chose to wear reflected who they were. His time with the band between 1965 and '67 helps get inside each band member's unique approach to looking stylish: "my work with the Stones was based on honesty, a desire to communicate something about the Stones as people and not try and mask their personalities with any sort of technical or theatrical embellishments," Mankowitz said in 2015. "I think that that's why Andrew Loog Oldham liked the pictures and why the band were happy to work with me for such a long period of time, because I photographed them as they were."

On a macro level, if you examine the shots taken over the course of Mankowitz's

close relationship with the band, it's possible to see the '60s begin to unravel before your eyes. Clothes the Stones wore went from seriously sharp, Mod-style tailoring and ties to the early adoption of androgynous mix-and-match vintage pieces with a psychedelic twist – and so the fashion riot of the Swinging Sixties is unequivocally captured.

Although Mod was a phenomenon that would be covered in *Life* magazine's May 1966 issue, when Mankowitz first met the Stones and started shooting them in 1965, fashion purists might argue that the look was already over. One of the earliest pioneers was Bill Green who opened his shop, Vince, in Soho back in 1954 and sold distinctive menswear; his customers were mainly trendy, gay guys who loved the store's poppy vibe and lively clothes he imported into the UK, which were new and different. It soon became a mecca for founding Mods, who bought into its energy and made it street-smart. Mod menswear evolved into a slick look that at times took influence from Italian tailoring: mohair bum-freezer jackets and tight pants equated to living the Dolce Vita, especially if you had a scooter to ride. When the Rolling Stones started out in '62, their look was clued-up Mod and they were a fan of John Stephen, Vince's sales assistant who went on to become the "King of Carnaby Street", opening 15 shops eventually, all selling his carefully curated selection of Ivy League preppy-wear, adopted and adapted by "faces" all over the country who flocked to discover the latest silhouettes he had on display.

By the time Mankowitz's first 1965 shoot with the Stones took place, their Mod styling began to hint of a slightly more flamboyant phase that would herald Carnaby Street's complete metamorphosis into the heartland of young and groovy boutiques. Fashion legend Tommy Roberts would open his phantastic shop, Kleptomania, just around the corner in Kingly Street, the following year: it was one of the first that would stock Victoriana and military threads, and helped catapult counterculture into a radical new dimension.

Mankowitz's 1965 images taken at Mason's Yard in Mayfair show the Stones in this groovy Mod phase. The one colour shot reveals their clothes run a spectrum of muted, minimalist shades, still very much in tune with the continental, jazzy tip that metrosexual modernists embraced and felt smart.

Brian Jones' meticulously coordinated outfit shows a man who cares about what he wears: cream slacks; a brown, cable-knit, fisherman, polo neck; pale suede lace-up shoes; and hair cut into his signature bowl shape. Keith sports an identity bracelet, and stylized Anello & Davide-type Chelsea boots with a mini heel, while his cord jacket features epaulettes: a spruce detail. Charlie's Sta-Prest®, knife-edge jeans, button-down blue shirt, slip-on shoes and ivory single-breasted jacket evidences the flair he would flourish forever, while Bill's jumbo cord blouson, a dad-core classic today, was a fresh sartorial choice at the time. Mick's outfit signals more informality: his brown check trousers are teamed with the same shoes Brian wears, but his jacket is suede and underneath is a simple T-shirt.

Hair is key to the overall mood of the fashion statement being made in the first photo shoot by Mankowitz. It's longer, growing out, and has swagger, but there was conscientiousness in its carefreeness – as revealed by a 1965 Mankowitz shot of Brian having his locks groomed taken backstage at New York's NBC studios while the band were there for a music show called *Hullabaloo*. "Brian would have his hair cut at any opportunity," recalls Mankowitz. But however many times they visited a barber, fringes always swept past eyebrows, deliberately overgrown, a sign of self-confidence and an insider sense of what looked right. More of which was to come as the year moved on and fashion began to loosen up and follow in the same way.

Most of the shots Mankowitz took of the band on the 1965 US tour are candid, fly-on-the-wall images that tell stories of the everyday, pictures that aren't staged or manufactured. You get an idea of life on

the road unfiltered. The images begin with the boys in the VIP lounge en route; Keith is wearing ombre-lensed shades, a premonition of the rock 'n' roll styling he was to become famous for. The contrast between the Beatles and the Stones is underpinned by a picture of Mick sitting waiting for the plane reading a newspaper article about the Beatles; you can catch a glimpse of the Fab Four, who are, if you look closely, wearing matching suits. In the backstage images and beyond that Mankowitz takes, it's clear that the Stones aren't identikit in the same way and their personalities, fashion-forward from the start, materialize. Brian and Mick, Keith, Charlie and Bill don't wear the same clothes, although they may shrug each other's on for size occasionally. It's hard to reconcile how radical the boys were with the clothes they wear, but on the TWA flight, sitting behind Keith and Mick, is a man in a white shirt and tie next to a woman wearing, pearls, a shift dress, glasses and a perm. Within this context of a mainstream manifestation of conventional fashion, very much stuck in the '50s, it is fascinating to scrutinize the Stones' rebellious styling, which conflicts with the strait-laced look of their fellow passengers. The boys' youth, and flair, is a contrast.

Brian's black polo neck and peacoat is directional and reminiscent of the work of designer Hedi Slimane at YSL during the early 2000s, whose references played on youth and subcultural fashion. Menswear in the '60s was about messing with rules and convention. In another shot, Jones sits beside his then girlfriend Anita Pallenberg, who wears an oversized, shaggy fur, monochrome bomber jacket and dark sunglasses. The couple's hairstyles are the same and together they represent the beginnings of a gender-fluid and progressive sensibility that would go on in the later '60s to further dismantle past wardrobe paradigms.

Mick in the limousine that collects the band from their flight in New York wears a leather biker jacket that juxtaposes with his unkempt shoulder-length hair and dark-rimmed eyes; a sense of ambivalent sexuality is portrayed that prefigures by five years his character Turner in the 1970 film *Performance*, where self and gender is further explored through clothes.

The band easily played with identity stereotypes. In 1966 they released a video for the single 'Have You Seen Your Mother, Baby, Standing in the Shadow?', where they dress up as women. It's an extraordinary piece of film; they play their drag outfits for laughs and each become cartoon versions of elderly female types of the time, establishing the distance between the age divide ruthlessly. Brian and Bill are war veterans – provocative and disrespectful to a generation who had recently lived through battle – while, Mick, Charlie and Keith are ancient spinsters clutching handbags. When they are not acting the maiden aunt, the band stroll through London's flea markets, and rush around wearing the latest hip clothing picks: patterned velvet and deadstock military jackets and oversized polka dot kipper ties – clothing that was synonymous with the peacocking dandyism they were beginning to personify.

In almost all the onstage shots taken by Mankowitz in America, the band wear Cuban block heels, and with every frame taken move discerningly towards brighter shirts, op-art patterns, louder trousers and assorted, vintage pieces – looks that would evolve into the full blown, deconstructed, free-spirit vibe of the latter part of the decade. Mick's hair gets even longer, and in one picture he pre-empts a freaky maverick trend, itself inspired by the Art Nouveau and Aesthetic Movement of the mid-nineteenth century, by wearing a boho, pale blue Paisley shirt with dagger collar while singing into Elvis's microphone at RCA's studios. Keith is photographed riding in Arizona – dressed as a cowboy with jeans, waistcoat, boots and a Stetson, sowing the seeds of his later laissez-faire rock 'n' roll chic. The Rolling Stones in Mankowitz's photographs are becoming fashion role models, and on return from the tour Mick wore a replica Victoriana tunic from I Was Lord Kitchener's Valet for a May 1966 episode of to sing 'Paint It Black'. The next day the shop

had 100 fans waiting outside to buy the same.

In the second half of the '60s, men became fashion exhibitionists and if you were far out, you might wear a frilled or satin shirt from a young label called Sam Pig In Love, to be found in Kleptomania's store. Jimi Hendrix was a fan. Mick Jagger showed one off when he played the Hollywood Bowl in July 1966, according to online blog C20 Vintage Fashion, which shows an image of Jagger in a sunflower-yellow version. Bill Wyman reveals in his 1990 memoir, *Stone Alone*, that "our sharpest dresser, Brian, spent a small fortune at boutiques" and he would visit, along with Carnaby Street, the King's Road "to Chelsea Antique Market for a spree typical in its list of exotic purchases: a mandarin coat, a pink fringed coat…velvet jackets…kimonos…tow strings of bells, a blouse, and a beaded belt…. In New York too, Brian had indulged himself in expeditions to the ladies jewellery departments of such stores as Saks Fifth Avenue and Bergdorf Goodman… A NY journalist friend commented: 'if he gave nothing else to the world, Brian was the first heterosexual male to start wearing costume jewellery from Saks Fifth Avenue.'"

The 'At Home' images Mankowitz took in 1966 show the boys in quirky states of bohemian domesticity. Brian is featured in his South Kensington pad and is, by this time, the most hippified of the band. Gered calls it a "chaotic" flat and Jones' outfit is a labyrinth of references. In one image he wears a white silk blouse, with balloon sleeves, teamed with a Beau Brummell cravat in the same fabric and accessorized with an exotic metallic headpiece adorned with medallions and macramé imported from the East. Brian's famous bowl haircut has a fringe growing beyond his eyes, and mutton chop facial hair is sprouting. In another shot, Keith wears the same blouse and cravat, signifying what a pick and mix accumulation of guises they enjoyed. In another shot from the series, Mick in his mansion shows off his walk-in wardrobe, wearing a trippy pea-green and purple swirled print shirt and pinstripe trousers along with a cobalt blue stone ring. In the background there are racks of similarly dazzling pieces: it's a rockstar dressing-up wardrobe deluxe.

By 1967, when Gered would take his final shots of the band at Olympic Studios, the band had become fully immersed in a drug-fuelled, flower child aesthetic. Images show Brian dressed in a raspberry-coloured velvet cape and cream vintage lace blouse featuring frilly cuffs and collar teamed with a diamanté necklace and a camel-coloured snood. He is fully wrapped and draped with rings on fingers and bells on his toes. Mick embraces the exoticism of brocade silks and sports a floral embroidered Nehru-collared jacket. Keith is trashed, but his style pervades: he wears a faded military jacket worn as a cape tied with silver thread, a skinny monochrome scarf, red beads and badges and multiple oversized bangles. Charlie Watts is the only Stone whose vibe is more classic. Known in retrospect as the most stylish member of the band, he largely looked to Savile Row for his wardrobe.

Gered's fêted shot of the band on Primrose Hill, which went on to become the cover

of their January 1967 album, *Between the Buttons*, shows the band huddled in reefer coats, Keith in shades. Charlie Watts is, as ever, wearing a shirt and tie. In all of Mankowitz's images, Watts's love of traditional menswear is revealed. He got the bug early when he was taken by his father to a tailor in London's East End as a young man. By the time he died in August 2021 he reportedly had over 200 Savile Row suits. Dario Carnera, previously head cutter at one of his favourites, Huntsman, told *New York Times*' writer Guy Trebay: "Mr. Watts was one of the most stylish gentlemen I've had the pleasure of working with. He imbued his own sartorial flair in every commission."

When it comes to choosing a favourite Stone look, it's a tricky pick to make, as their legacy spans decades – and apart from Charlie, they move and shake along very different style paths. Perhaps it's an irrelevant question to ask. It's always special to know someone when they are young, and Mankowitz's time with the Stones, between 1965 and '67, is golden Stones time. They were rebels with a musical and fashion cause, part of a wave of cultural change and at the cusp of a kind of everlasting superstardom that would be as surreal and kaleidoscopic as their wardrobes. For Gered Mankowitz it was, he declares, "a dream come true".

Terry Newman is a fashion writer, presenter and lecturer at Regent's University, London. Formerly an editor at *i-D* and *Attitude* magazines, she worked in the fashion industry for more than twenty-five years.

Primrose Hill

1966

Around the autumn of 1966, the guys were recording tracks for what would be the *Between the Buttons* album at Olympic Studios in West London. I attended several of the sessions, which always took place throughout the night, to the early morning.

Photographing these sessions was tricky. It was almost impossible to get the whole band together in the studio and the backgrounds were often intrusive, with harsh vertical and horizontal lines. I began to develop a filter for my camera, made of black card, a piece of glass and Vaseline, in an attempt to blur out the background. The filter worked beautifully and, early one morning as we tumbled out of the studio into the dawn, I realised that the guys, although exhausted and hung-over, looked fabulous – exactly as the Rolling Stones were supposed to look. I proposed that we shoot a session after one of these all-nighters for the cover of the album, and that I use my filter. To my delight, everybody agreed, and it was arranged for a day or two later.

I had decided to take them up to Primrose Hill in North London, one of the highest points in the city, in the hope of getting some decent early light. A fleet of cars took us on a cold November morning and we tramped up the hill to a point I had earmarked. As we ascended, we started to hear flute music. Looking at each other with a certain disbelief, and not sure if it was the morning joint or what was indeed happening, we saw ahead of us a skinny dude with long, lanky hair, playing the flute. As we approached, he stopped and saw the Rolling Stones approaching – and, as Mick offered him the joint, said, "Ah, breakfast!"

Despite the early hour, the band responded marvellously to the situation, except for a brief moment when I was concerned that Brian was not cooperating, burying himself into the collar of his big fur coat and looking away into the distance. But Andrew assured me that the band had reached a point where it didn't matter what Brian did, that his presence in any way would only contribute to the image of the band – and how spot on he turned out to be! The shoot lasted only about 45 minutes before exhaustion and the cold overtook us all, but we got a great series of portraits and one of them was selected for the album cover, one of the most important of my career.

PRIMROSE HILL

PRIMROSE HILL

A1

A4

A2

A5

A3

A6

A10

A8

A11

PRIMROSE HILL

PRIMROSE HILL

The London Palladium

1967

In January 1967 the Stones were booked to appear on the most popular television variety show of the age, *Sunday Night at the London Palladium*, which was broadcast live between 8 and 9 p.m. every Sunday evening. It was a massive show and, for many, the pinnacle in their careers. But for the band it was just another TV show and an opportunity to plug their latest record.

I went along to cover the rehearsals and backstage but wasn't allowed to shoot the actual broadcast. Everything appeared to be going smoothly with the rehearsals, but there was an odd atmosphere in the dressing room, a tension in the air that nobody could really comprehend. Both Keith and Mick seemed troubled. As the scheduled time of the performance was approaching and everybody was being made up and changing into their finery, all seemed good – and the actual performance seemed to go very smoothly. But at the point at the end of the show when all the participating artists were supposed to gather on the stage carousel to grin and wave at the audience of millions watching in their sitting rooms around the country, the Stones refused! They point-blank refused to go on, causing an absolute scandal, with massed headlines the next morning condemning the band and giving them more column inches than they could have even dared hope for. Apparently, Mick felt the band had conceded enough just by appearing on the show and that the carousel was simply a step too far. But we will never know if the whole episode had been pre-planned or not.

THE LONDON PALLADIUM

THE LONDON PALLADIUM

THE LONDON PALLADIUM

THE LONDON PALLADIUM

Olympic Studios

1967

After a spring tour of Europe, complete with a clutch of the now regular TV appearances made by the band, the Stones were in Olympic Studios again to work on a new album. I covered several of these night-time sessions, as I had previously. But this time the mood had changed, and the atmosphere was difficult, to say the least.

Brian was in a bad way and was frequently not up to much, at one moment recording an important contribution to a song and then in the next collapsing into his food and needing help. It was sad, difficult and increasingly uncomfortable. Andrew, who by this time had become a dear friend of mine, was finding it very hard to keep it all together.

The band were locking us out, and there was an increasingly cliquey atmosphere about them, with new friends and associates, including the photographer Michael Cooper, being part of the picture and the band often not turning up until one or two in the morning – drunk, stoned or both – and increasingly aggressive towards both Andrew and me.

For me, the end came when Mick, completely ignoring me, went to Andrew and told him that Michael Cooper was going to photograph the new album cover, no debate. I knew then that it was all over for me with the Stones – and probably for Andrew as well. My career continued elsewhere and went from strength to strength. I continued to see the band socially but didn't work with them again until a session in 1982 for the London *Observer* magazine – by which point they were an entirely different band.

1967

OLYMPIC STUDIOS

This is the last photograph I took of Brian Jones, and marked the closing of my chapter with the band. It's a poignant picture for me, taken during what, looking back, was a pretty awful time. Brian looks exhausted, haggard even. The experience of those last few nights at Olympic was not pleasant. There was a terrible tension within the band, even more so between the band and Andrew, and I knew that my days with the group were numbered. And then it was over, and that was that – two years of working with the Rolling Stones finished and time to move on, with an archive of photographs, enduring friendships and wonderful memories to last a lifetime.

A Different Class
Peter York

The most exciting visitor to my schoolboy world was my mother's friend and neighbour, Celia Oldham. Her son, Andrew Loog Oldham, was out in the most exciting bit of The Great World possible, as manager of the Rolling Stones. His mother's stories – where he'd been, who he'd met – were literally thrilling.

But what did the Rolling Stones ever do for the nation?

They were clearly influential in all sorts of ways if you were in the business of riffs and licks or were a crazed music journalist, but how much wider did it all go?

The Rolling Stones were central in moving young Britain's post-war affair with Black America – its music, culture and people – into the mainstream. Black America – or, more precisely, its blues music of the Muddy Waters, Howlin' Wolf or B.B. King variety – brought Mick Jagger and Keith Richards together. They were Home Counties suburbanites – Jagger distinctly more straight-A, middle-class than Richards. They'd practically always known each other, at primary school and as near neighbours in Dartford. However, it was the famous show-and-tell Dartford railway station meeting on the morning of October 17, 1961 that bonded them together for the next sixty years. Jagger was by then commuting to the LSE, Richards was at art school. And it was the imported American blues albums Jagger was carrying that got them talking, then going round each other's houses – and then working together.

A taste for the blues was already a minority badge of honour for a small earlier cohort of Brits then reaching their thirties – people like Alexis Korner, the distinctly middle-class bluesman that Mick, Keith and Brian got to know in London a couple of years later. This small, dedicated group wanted to meet their heroes and visit the *real* America. They were keener on *authenticity* than pop success.

But as the '60s got started, a new taste in Black American music was developing. A taste for crossover music and pop performers from the Shirelles and the Ronettes to the emerging *Billboard* mainstream of Motown, or the sophisticated soul from the Memphis label. A taste championed by Young Brits and emerging popstars like Dusty Springfield. This was music that was marketed to go wide in America and, later, to sell in world markets. And no market was earlier or more enthusiastic than the UK. From the working class in port cities like Liverpool to London Mods to the growing university population, there were more white teens who thought American Black was beautiful here than in the rest of Western Europe put together.

The two defining British bands of the early '60s, the Beatles and the Stones, were more alike than they seemed, and they certainly had a mass of US Black influences in common. But they were marketed differently by their first managers, Brian Epstein and Andrew Loog Oldham. Epstein cleaned up the rough Beatles for mass consumption showbiz, while Oldham dirtied down the relatively middle-class, southern Stones and told them to be bad – the anti-Beatles. They spent more time – especially Brian Jones – in

interviews talking up their Black bluesman enthusiasms for a different market segment, bringing those names to mainstream media.

But it was more than just the music. The Stones weren't meeting Elvis, like the Beatles famously did; they were sharing platforms with their Black heroes like Muddy Waters and Tina Turner. In their music, their aesthetics and their lives, the Stones helped push us – the European nation most at ease with itself about race – that bit faster along the road we wanted to travel.

The same is true of their lifestyle. In his definitive biography of Mick Jagger, Philip Norman quotes him talking about his life choices in the 2002 documentary *Being Mick*. Sir Mick Jagger said of relationships that he had a "bohemian, artistic attitude to love and marriage".

In the '60s, they famously said of the sexy young fashion photographer David Bailey that he made love daily. They couldn't say that of Mick Jagger because almost everyone in the nation was convinced that he did it *hourly*. The Stones – and Mick Jagger in particular – were sexy. They seemed miles sexier than the Beatles, whose rough real lives had been sanitized by Brian Epstein for universal appeal. And drawing on their Black American musical heroes, they sang about very directly sexy things for anyone who could decode the old bluesmens's argot.

As Philip Norman makes clear, Jagger wasn't anywhere near early '60s standards of male beauty; look at contemporary actors and models. But he was precociously attractive to girls – and sexually active early by the lights of the early '60s.

PETER YORK

But from the beginning, there was a constant question: What sort of sex are all those symbols and tells promising? A little bit of eyeliner goes a long way in public life, and, starting in the later '60s, Mick Jagger sometimes seemed to be wearing blue eyeshadow and a bit of lippy too. And he was taking his shirt off on stage ages before the middle-class rock gods of '69 through '72 had thought of it.

David Bowie first cemented his fame in January 1972 in a *Melody Maker* interview with Mick Watts where he said he was bisexual. But from those first Andrew Oldham days, Jagger had the power to excite women – who knew exactly what he was getting at – and to worry men, who often didn't. He didn't need to talk like a provincial academic about "androgyny". It seemed to come naturally. Young men who found themselves disturbed by the Jagger approach could reassure themselves by falling back on the Black bluesman authenticity of the rudery, and the famous trail of beautiful women in Jagger's life, to reassure themselves that they were in no danger.

Brian Jones, with his '60s golden-helmet hair and his obviously attention-seeking poses, had aroused the same comments in the early days. In fact, Jones had had a first child when he was 16 – scandalously, with a girl of 14 – and there was nothing remotely androgynous about the other Stones. But Jagger, as a definitive new kind of pop star, set up a number of archetypes in the culture – the first was the no limits rock god (though clearly not a brawny axeman), and the other was the precursor of the 1970s' androgyny of glam rock, at both the mass level of, say, Slade or the Sweet (a scene once referred to as "hod-carriers in Bacofoil") or at the art school, pretentious level of Roxy Music and David Bowie.

There've always been stories about Jagger's pouty, posy stage sexiness spilling over into real-life gay affairs – allegedly one with David Bowie in the '70s (or others referenced in Marianne Faithfull's later autobiography). But Philip Norman thinks this was all a conscious, image-building tease – chic before its time. He says Mick was really spending the time doing press-ups or counting the ticket sales. But look at *Performance*, filmed in 1968, and you'll see that hugely influential tease in action.

In the early 1960s the calling of rock star wouldn't have cut much ice in Eaton Square. You can imagine that the very occasional rogue deb might've invited a headliner from *Thank Your Lucky Stars* there to annoy her parents. But you'd have been more likely to see a supper club, soft jazz act in his thirties, someone with impeccable manners.

In this era, British popstars came from a hilarious minor branch of show business where predatory managers – often gay men of the Larry Parnes variety – put former tyre mechanics on the stage as pale imitations of their US archetypes, such as Pat Boone or Buddy Holly. Their market was early and mid-teens, more girls than boys. There was nothing for older middle-class boys, let alone for students, whose numbers were set to explode. That all changed in the '60s, with new music for practically everyone, and a hugely wider range of performers with different backgrounds, ambitions and musicianship. Performers as pretentious as John Lennon with his art school chat and political slogans. Performers with as solidly studenty – even Oxbridge-y – a collective style as Manfred Mann.

Or straight-A, middle-class grammar school boys like Brian Jones from Cheltenham, who seemed set for university but unaccountably didn't go. Or his Rolling Stones bandmate Mick Jagger, who did, to the LSE. Jagger, under Andrew Oldham's guidance, soon morphed into a different creature entirely, a Bad Boy from nowhere who replaced his polite, correct, and proto-RP style with a hilarious but widely copied accent, one known as *mockney* decades later.

But if you listen to what Mick Jagger actually *says* in interviews over the last 40 years – meaning the words he uses and the way they're arranged – you realize that he really talks like what I would call your average

superannuated groovy toff from the likes of Chelsea.

Jagger has established rock stardom as a suitable career for gents. He's been a fixture in smart country houses since the later '60s, when a new generation of toffs and established plutocrats were as infatuated by rock stardom as their predecessors were by, say, Noel Coward or Cecil Beaton between the wars. And how lovely to find someone cool – a major trophy at your parties – who actually knew how to behave and who'd understand your house, your pictures and your landscaping.

Mick Jagger's first proper house was at 48 Cheyne Walk, SW3 – Chelsea toff heaven (Keith bought one down the road at No. 3, somewhat later). He's never for a moment, it seems, considered a footballer McMansion in Wentworth or Stanmore – a latter-day Graceland. Start as you mean to go on. And you can see how he went on from the documentaries that've followed. A perfectly sized chateau in France. An elegant brownstone in New York and a Florida lakefront house.

From the pictures his various houses look comfortable, relaxed and elegant. But look closer, remembering he's been around toffs for more than 50 years and around the super-rich too. He's met the kinds of artists who'd have wanted to meet him (Hockney and Bacon obviously). He says he's not a collector in the obsessive sense, but just watch him buying $13,000 worth of rare books in that 2002 documentary, and you'll get the message.

The Rolling Stones were arguably the first group to make their band a brand. Now absolutely everyone talks about their *personal brand* and their corporate brand, and about the platforms they inhabit. But they didn't in 1970, when the Stones logo, the outward and visible sign of this process, was first used. It featured huge lips, an exploring tongue and a cavernous mouth. In the following years, it was rolled out to become the theme of their stage design for events everywhere.

Now that logo is in all those designers' books as a Top 10 post-war corporate device. The brand thinking that made the Stones a proxy for a certain set of attitudes, a certain kind of implied hypersexiness, and a certain kind of musical experience, also meant you could switch people around, even substitute them if you had to. Not like John, Paul, George and Ringo.

The logo, and therefore the brand, was overwhelmingly and irreplaceably Mick. Added to the IP he had in the Stones original Jagger–Richards music, written after the band moved from the old American bluesman cover versions of their first incarnation, it increased Jagger's influence. Increasingly, it appeared that Jagger became the CEO of the enterprise, taking care of business – from discipline at gigs to getting out of manager Allen Klein's clutches in 1970, when Klein's hold on the rights of the Stones early IP had become a problem. And in the twenty-first century, as the internet utterly changed the musicians' returns to their IP, so the Stones, already a hardened touring machine, became, *in their sixties*, one of the world's highest-grossing attractions. Some argue they were *the* highest grossing operation over the decades, slugging it out with everyone from U2 to Madonna.

Now, with Brian Jones long dead, Bill Wyman long deserted – in 1993 – and rock-solid Charlie Watts passed away in 2021, there's every chance of another world tour led by the two key octogenarian Glimmer Twins, Mick and Keith. They've been on the road for sixty years. The Beatles, as Philip Norman points out, managed nine years together, max.

Ronnie Wood, the archetypal British Rock OAP with his raven bog-brush hair and long cavernous pale face, is the old New Boy, drafted in from the Faces in 1976. The Stones all look so marvellously old it's become part of the brand, the demonstration that oldies are doing it for themselves. And for their long-time loyalists, it's an endorsement of their cohort and their shared experience. Ambitious younger musicians have taken their cue from the Stones's astonishing organization and

discipline; they absolutely know they're in business and they're aiming for the long haul.

There are two sharply contrasted media images of Young Britain from the late '60s. One is the self-consciously "decadent" world of velvet clothes and the rich, dark Oriental druggy interiors of *Performance*, Mick Jagger's most important film, made in 1968 but not released until 1970. The cast barely get out of bed.

The other is political, out on the street, in increasingly angry anti-American, anti-Vietnam War protests like the 1968 Grosvenor Square Riots – paralleling what was happening on the Paris streets, the world of students and Danny Cohn-Bendit. The Stones, never particularly political, were already insulated from those streets by fame and wealth and their new smart louche friends in London and New York. (Just look at their New York pre-show dressing room full of people like Andy Warhol and Truman Capote in the BBC's *Crossfire Hurricane* documentary.) But they were highly sensitive to modish language and gestures, especially Mick – just like the clever ad men and PRs who, decades later, brought greenwash and "inclusivity" into the public presentation of politicians and corporations. The Stones' lyrics managed to suggest a 'Street Fighting Man' sympathy for the new politics without the remotest real commitment to them – though some point to 'Undercover of the Night', which is surprisingly explicit about human rights abuses in South America, possibly inspired by Bianca. It made the Top 20 but not No. 1.

The horrors of the Altamont concert in 1969 – when a Black audience member was killed by the Hells Angels, the organization

that had been recruited as security – and the famous drug bust of 1967, had taught Jagger to be very careful indeed. He didn't want to be banned from touring in the US.

If, as I have suggested, he was already developing a certain toff style of language, tastes and attitudes, Jagger was also developing a new and impressive skill that was practically *royal*. Key British Royal family members are taught from their early teens how to stay out of trouble by never saying anything remotely controversial about anything. They usually know the dangers of drunken candour and open mikes. Equally, Jagger's interviews that seemed amusing and almost candid at the time are actually amazingly free of direct controversy in retrospect.

The Stones had to be ever more careful – unlike royalty they gave long filmed interviews; unlike royalty there was no polite convention that you didn't rat on conversations with them. If you watch Jagger in those long interviews, he's brilliant at avoiding "difficult" questions, especially political ones. His tactic is to imply they're somehow gauche or *boring*, because you *knew* where he was at.

Amazingly, until well into the 1970s, a host of left and liberal activists, groups and individuals, went on petitioning the Stones to add their names – if not more active support and money – to their causes. They did it in the expectation that the Stones were somehow broadly on the side of the angels. The cues were in the lyrics, and in the all-purpose rebellious poses – *attitudes* that remained from Andrew Oldham's crucial advice that acting like rebels was the way to make themselves rich.

Those earnest petitioners found themselves unaccountably disappointed, but often put it down to the record companies and managers. It was hard to lose the collective investment in the mythology of the great '60s breakthrough as a sort of youthquake Arab Spring before its time. But as the '60s ended, depressingly, a new word had evolved in the activist language: "breadhead". Not, then, hipsters obsessed with artisan bakery but rather people who'd got the look and the language and all the ostensible pieties of Youth for Change off pat – people who passed for "heads" but whose real imperative, when it came down to it, was money.

The Stones were an object lesson in a new kind of "cultural appropriation" – as academics were starting to call it. Taking on a whole vocabulary of protest in a profitable nod and wink. As the Maclaren/Westwood "Seditionaries" T-shirt manifesto of 1976 said: *'you're gonna wake up one morning and know what side of the bed you've been lying on!'*. In the text that followed, the Stones – along with Brian Ferry – were supposedly on the wrong one.

Peter York is an author, cultural commentator and broadcaster. Style Editor of *Harper's & Queen* for ten years, he co-authored the era-defining book of the 1980s, *The Official Sloane Ranger Handbook*.

Afterword
Andrew Loog Oldham

GERED CAPTURED THE BLACK AND WHITE BEGINNING OF THE STONES. IT WAS MARIANNE WHO BROUGHT US TOGETHER. ROCK 'N' ROLL, AND ITS MOSTLY UNKNOWN R 'N' B BROTHER, WERE IN MONO AND LIFE IN THE UK WOULD REMAIN IN BLACK AND WHITE UNTIL DRUGS GAVE IT COLOUR AND OUR MUSIC, PERCEIVED LIFESTYLE, CULTURE AND LUST FOR LIFE WERE EMBRACED BY SO MUCH OF THE WORLD.

GERED'S FATHER, THE PLAYWRIGHT AND AUTHOR WOLF MANKOWITZ, ALSO BROUGHT US TOGETHER, BECAUSE HIS *EXPRESSO BONGO*, A SATIRE ON THE FIRST WAVE OF BRITISH ROCK AND POP, GAVE ME – VIA THE IMMACULATE PAUL SCOFIELD'S PORTRAYAL OF MANAGER JOHNNY JACKSON – AN IDENTITY SUIT TO WEAR, AN EXAMPLE TO GUIDE ME, AND PREPARE ME TO MEET AND GREET AND INTRODUCE YOU TO THE ROLLING STONES.

GERED TOOK HIS PICTURES IN AND AROUND HIS STUDIO IN MASON'S YARD AND THEN IN 1965, AS WE GAVE THE WORLD SATISFACTION AND PLAYED WITH FIRE, GERED JOINED US ON A TOUR OF THE US AND CAPTURED THE SHOWS, THE RECORDINGS, THE BACKSTAGE AND THE GROWTH OF THE BAND AND THEIR FIRST TASTE OF THE FUTURE. YOU NEVER SAW HIS CAMERA, HE *WAS* THE CAMERA, THE SAME WAY A GREAT SONG ARRIVES FROM ABOVE. THEREFORE, GERED WAS AT ONE WITH THE BAND. MORE THAN THAT, FOR THAT SPECIAL TIME, HE WAS IN THE BAND…

ANDREW LOOG OLDHAM

ACKNOWLEDGEMENTS

Acknowledgements

This book is dedicated to Julia, Jessica, Rachel, Lucas, Zachary and Ruby.

I would like to acknowledge the importance of Ian Stewart who was not only a co-founder of the Rolling Stones and a marvellous musician but a good and supportive friend to me during my time with the band. If you didn't have Stu on your side, you were in trouble...

Of course, I want to thank Mick, Keith, Charlie, Bill and Brian, without whom this book couldn't exist.

Andrew Loog Oldham for giving me the opportunity in the first place and being so supportive to me for nearly 60 years as well as throughout the production of this book.

Jeremy Clyde and Marianne Faithfull because none of this would have happened without them!

I also want to thank Will Hodgkinson, Ben Sisario, Dr Leah Kardos, Terry Newman and Peter York for their wonderful essays.

Joe Cottington and James Empringham as well as the whole team at Welbeck.

Carrie Kania and all at Iconic Images Ltd.

Blake Lewis and Adam Powell for all their hard work on scanning and post-production.